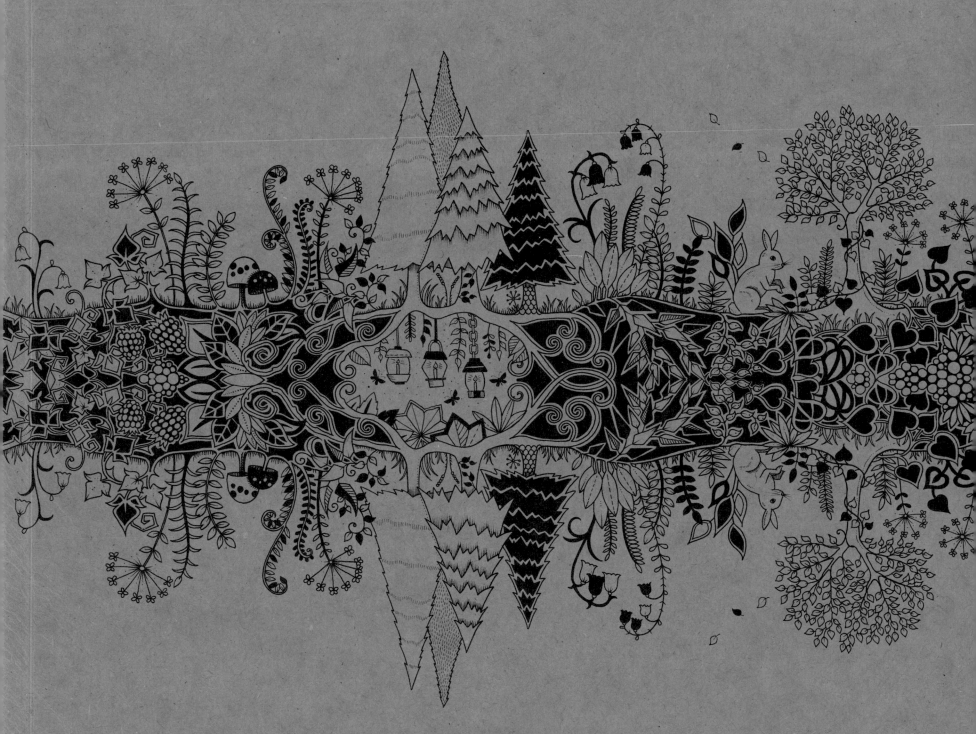

Tumble down the
rabbit hole &
find yourself in my
inky wonderland...

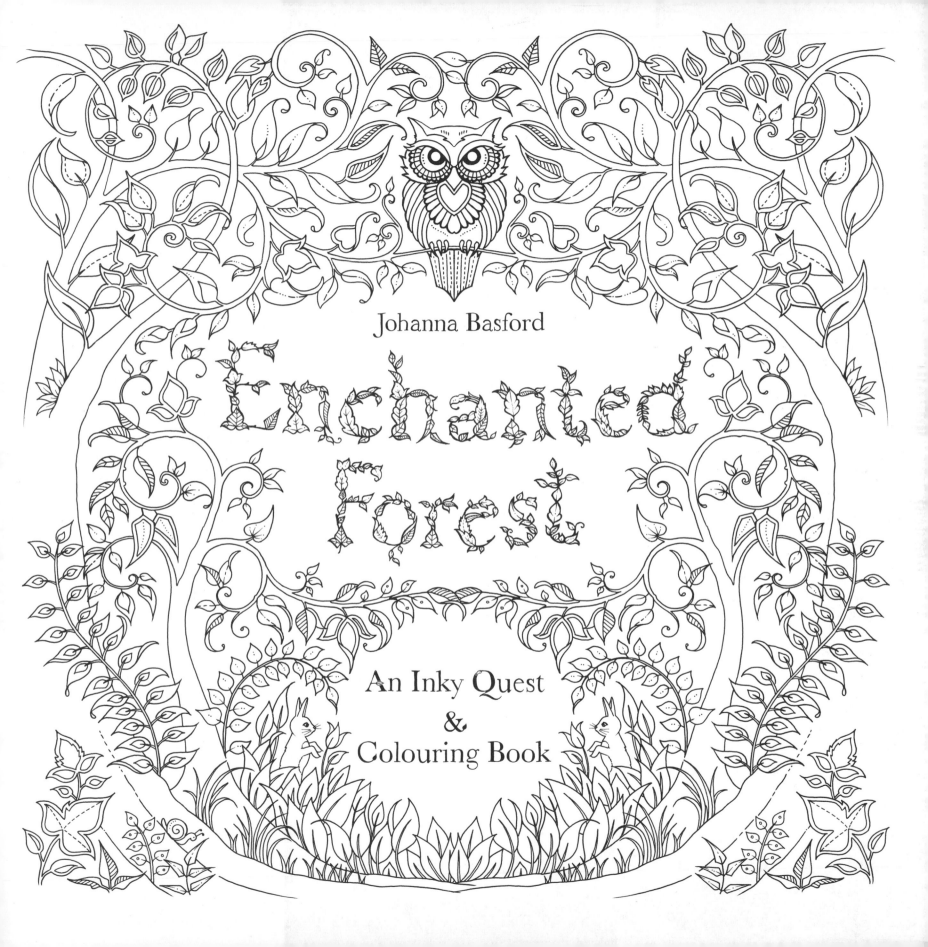

Johanna Basford

Enchanted Forest

An Inky Quest
&
Colouring Book

LAURENCE KING

Published in 2015 by
Laurence King Publishing Ltd
361–373 City Road
London EC1V 1LR
Tel: +44 20 7841 6900
Fax: +44 20 7841 6910
email: enquiries@laurenceking.com
www.laurenceking.com

Reprinted 2015 (twelve times)

A catalogue record for this book is available
from the British Library.

ISBN 13: 978 1 78067 487 2

Design: Alexandre Coco, Johanna Basford

Printed in China

This book belongs to:

Hidden inside this book are...

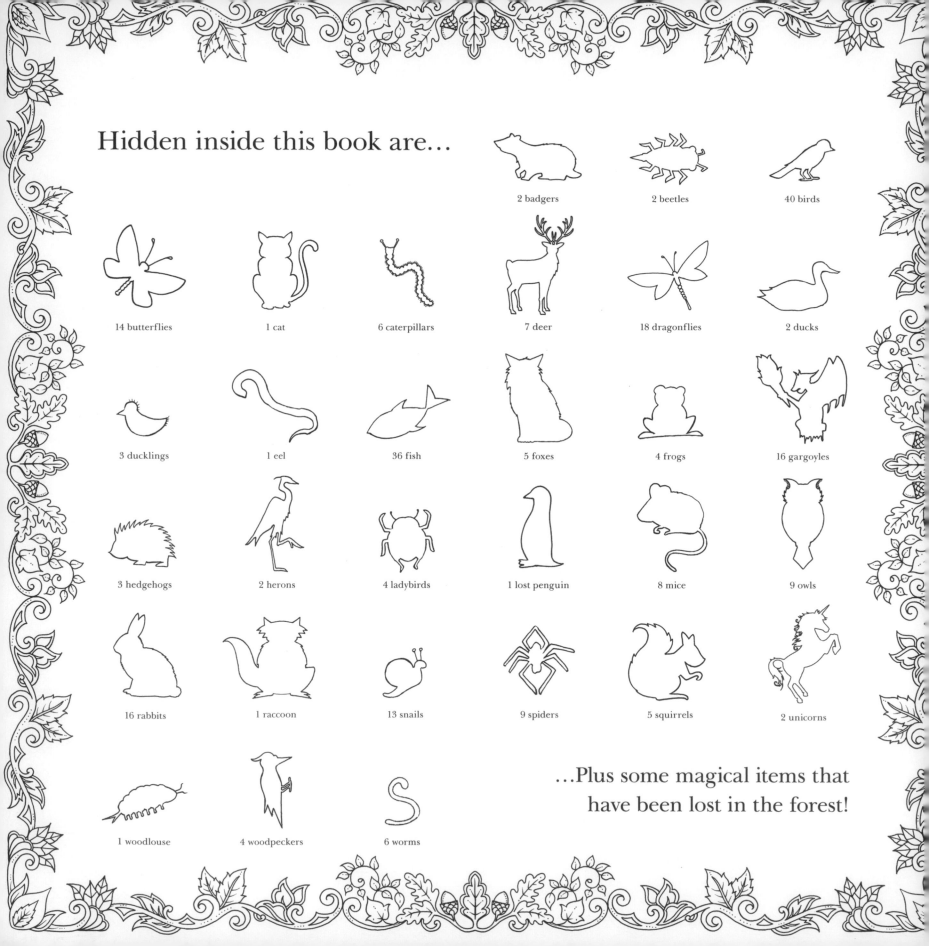

2 badgers

2 beetles

40 birds

14 butterflies

1 cat

6 caterpillars

7 deer

18 dragonflies

2 ducks

3 ducklings

1 eel

36 fish

5 foxes

4 frogs

16 gargoyles

3 hedgehogs

2 herons

4 ladybirds

1 lost penguin

8 mice

9 owls

16 rabbits

1 raccoon

13 snails

9 spiders

5 squirrels

2 unicorns

1 woodlouse

4 woodpeckers

6 worms

...Plus some magical items that have been lost in the forest!

Can you solve the quest of
the Enchanted Forest?

Inside this book is a wonderful inky
woodland full of curious creatures waiting
to be discovered and coloured.

Find your way through ferns and flowers,
magical tree houses and thorny vines to the
castle at the heart of the forest.

Hidden throughout the book are nine
symbols carved into square tablets. Find the symbols to
unlock the castle door at the end of
the quest and discover what lies within!

Use the Enchanted Forest key at the back
of the book to help you keep track of the
other things you find along the way.

Good Luck!

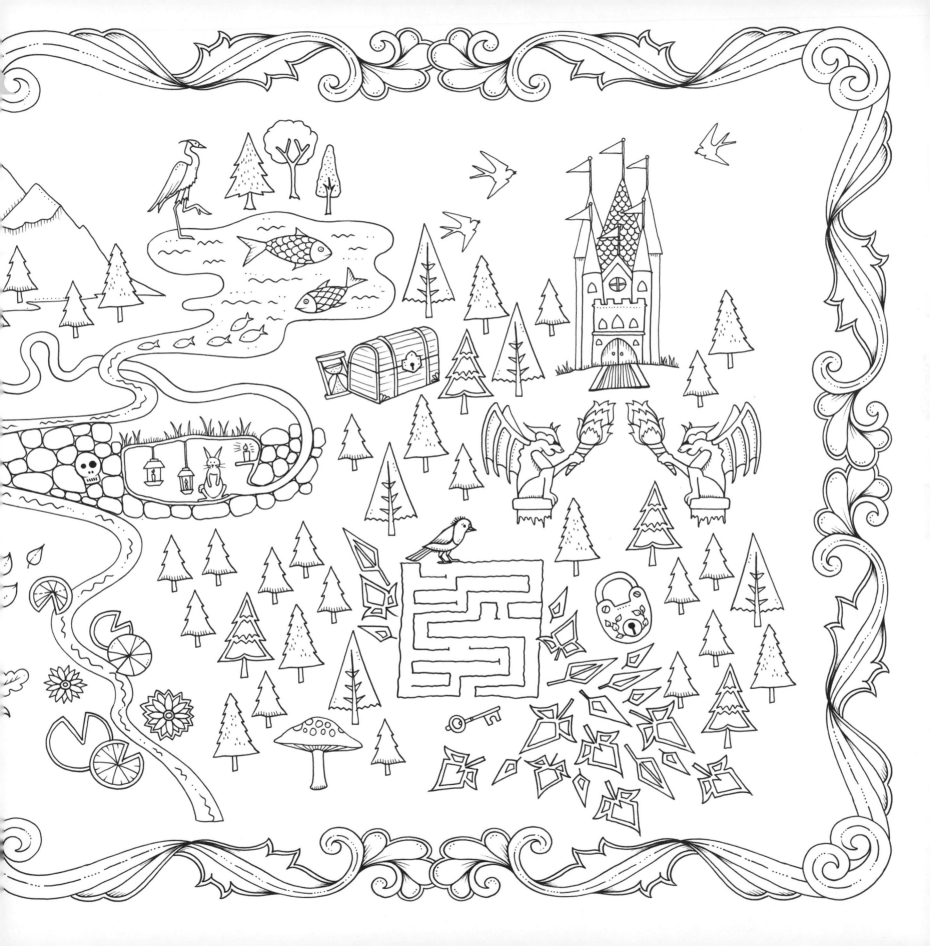

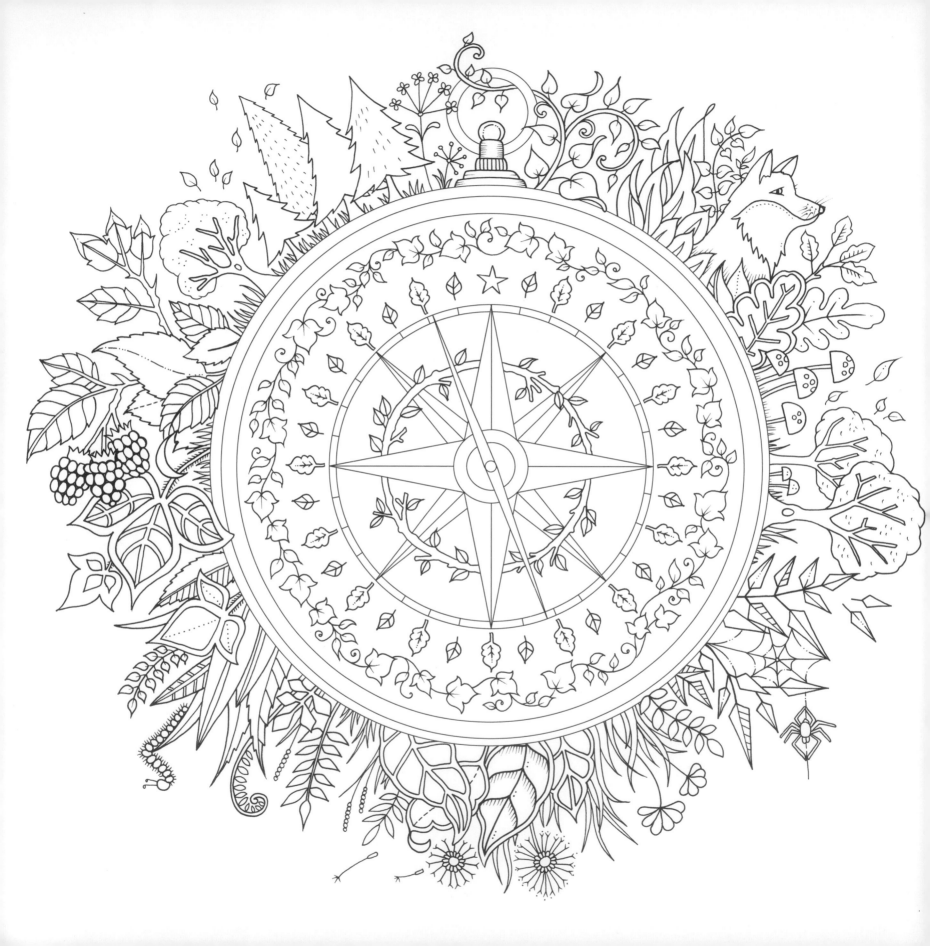

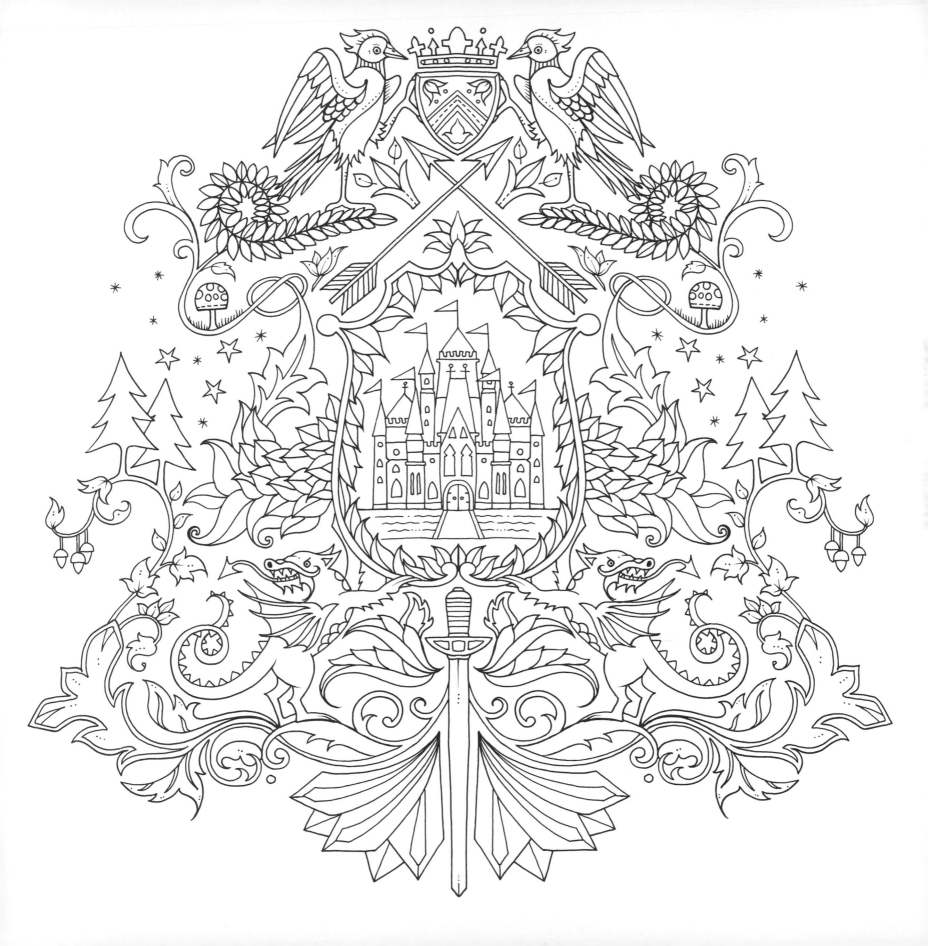

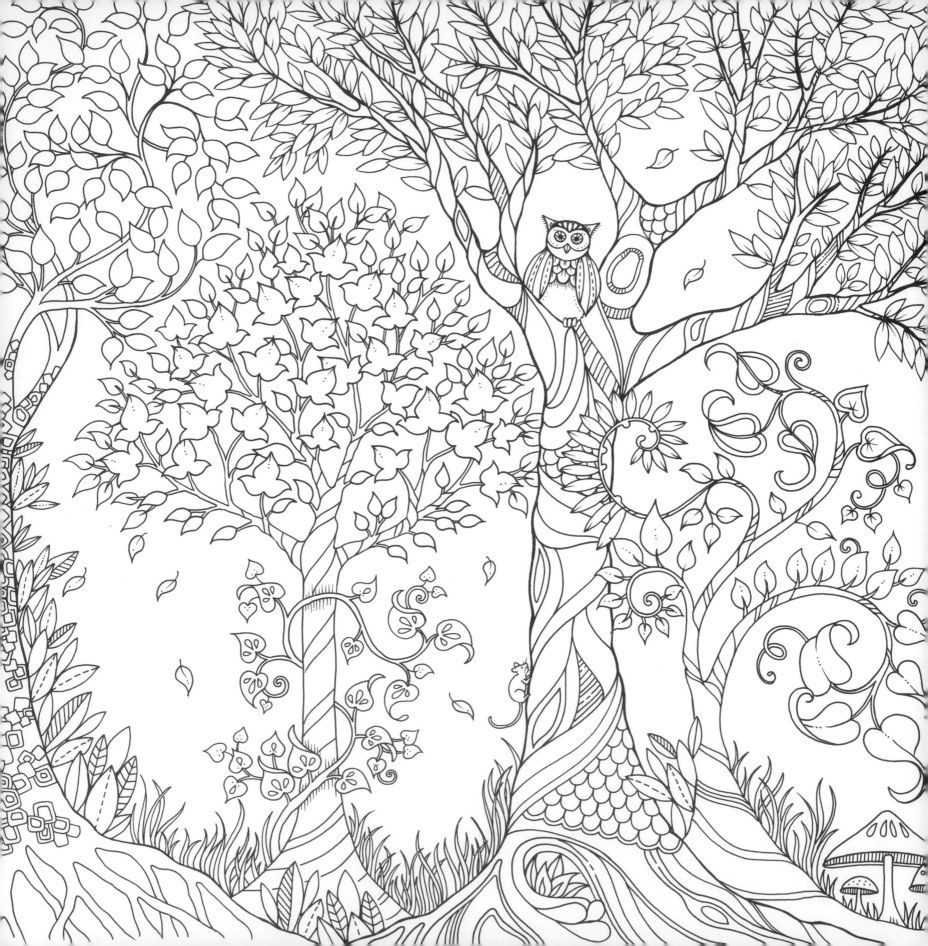

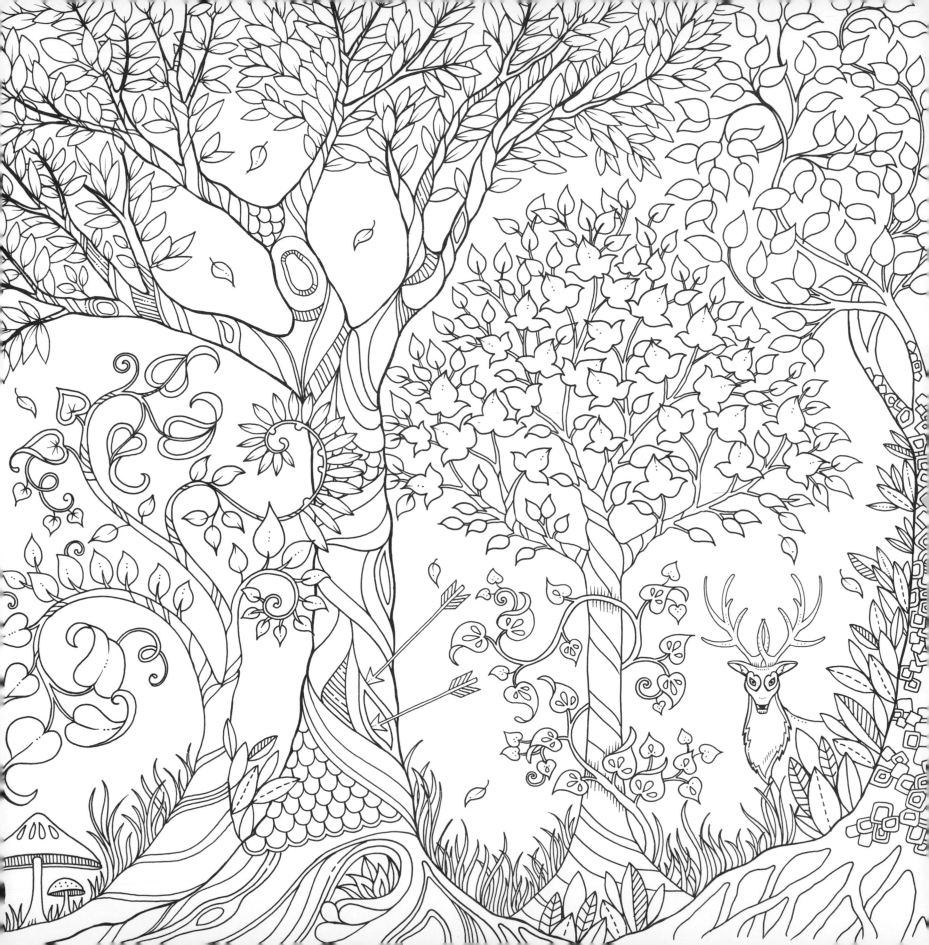

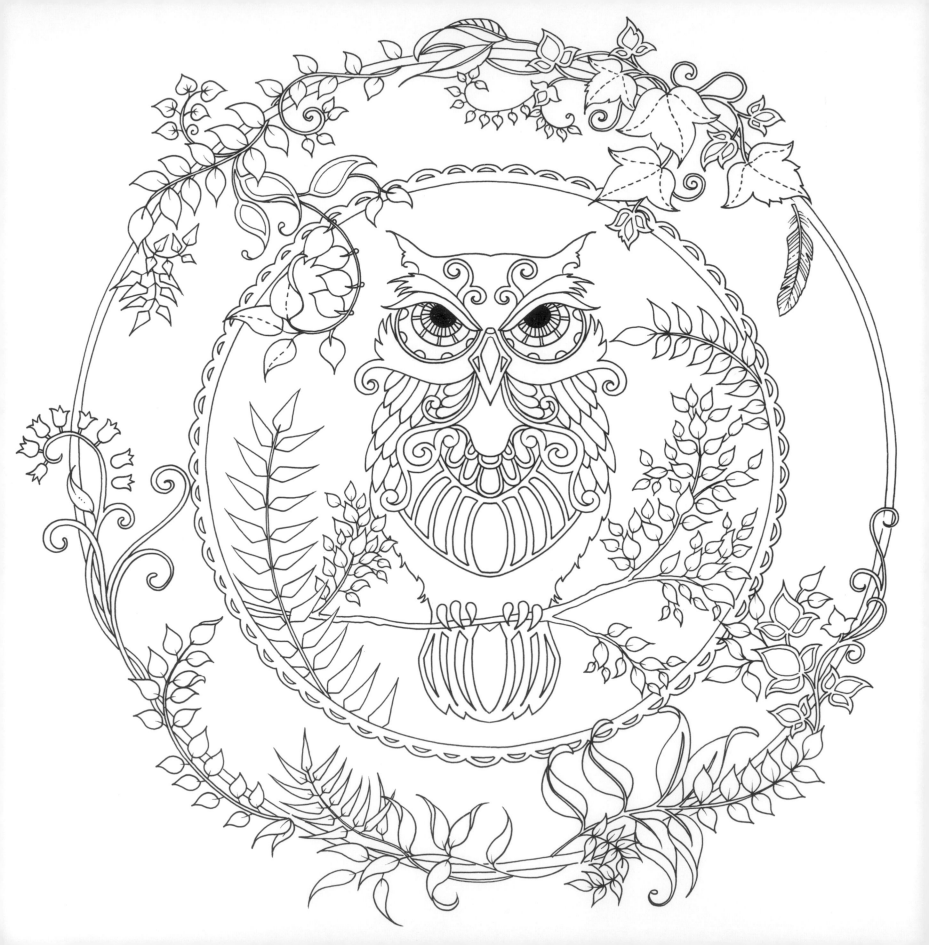

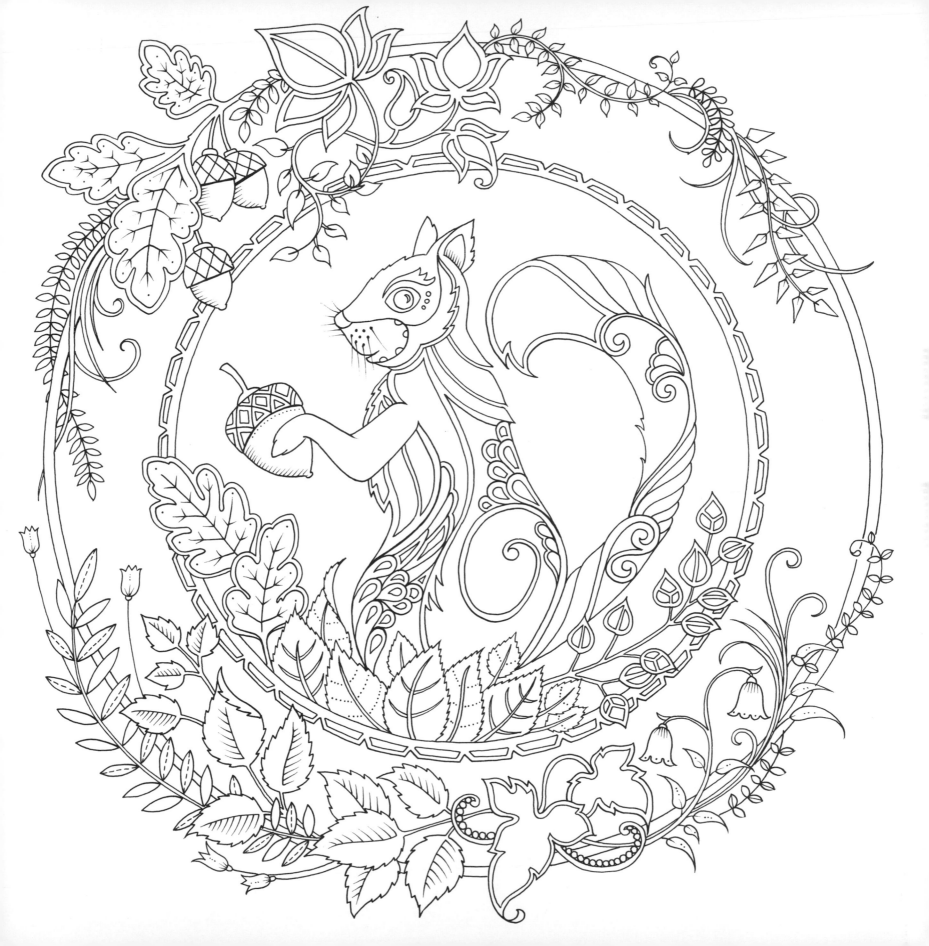

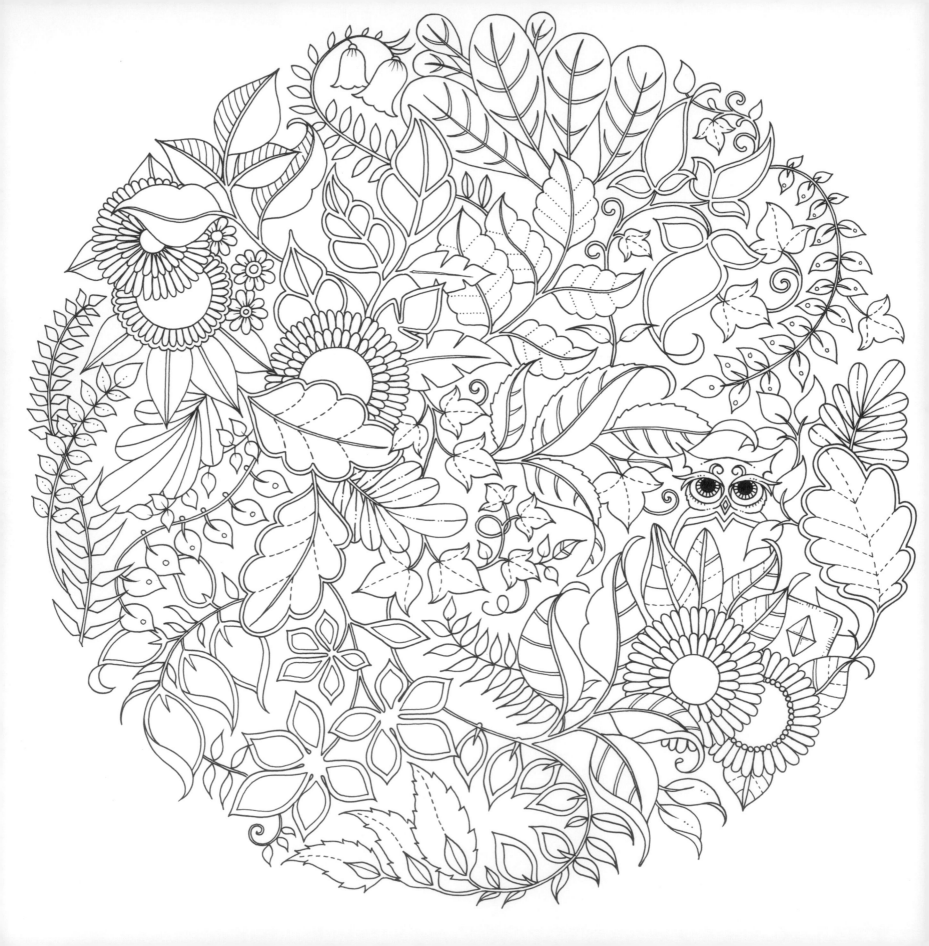

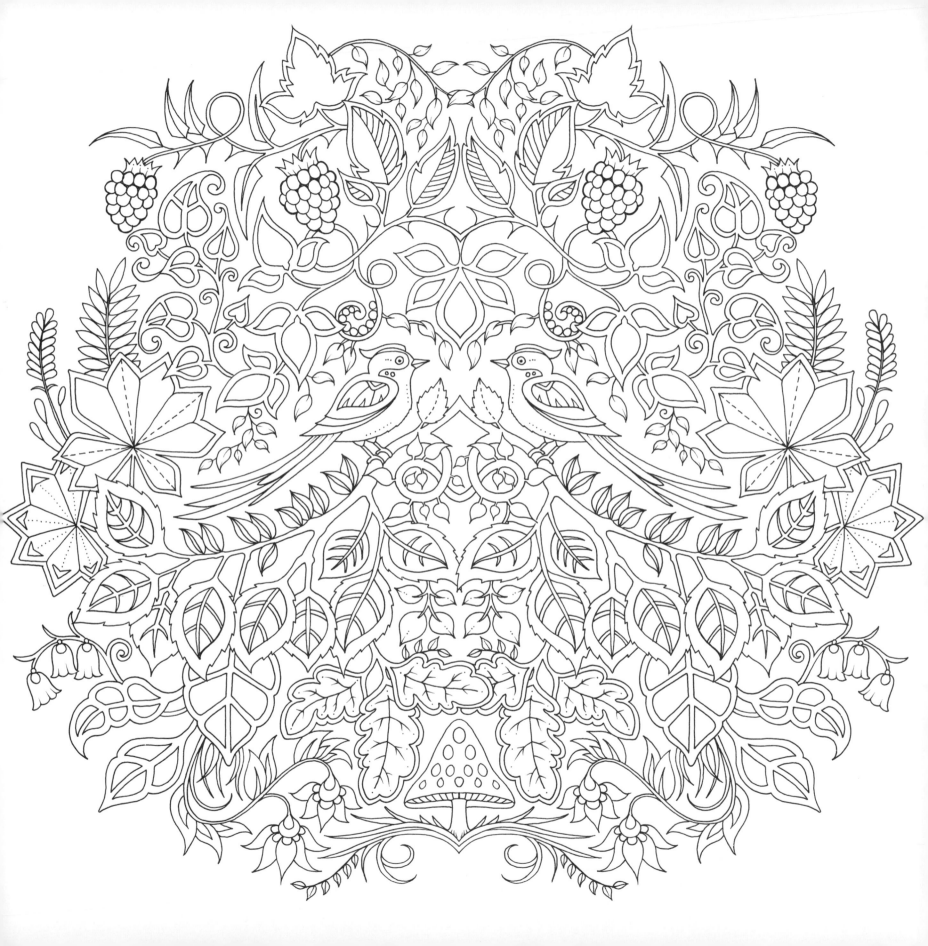

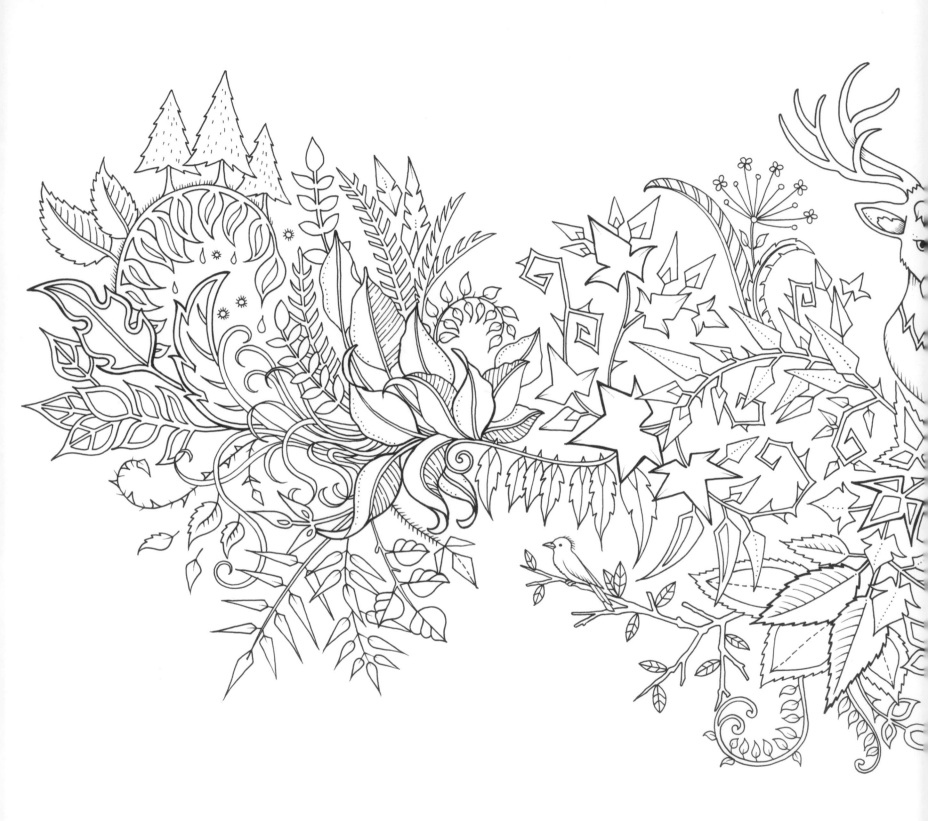

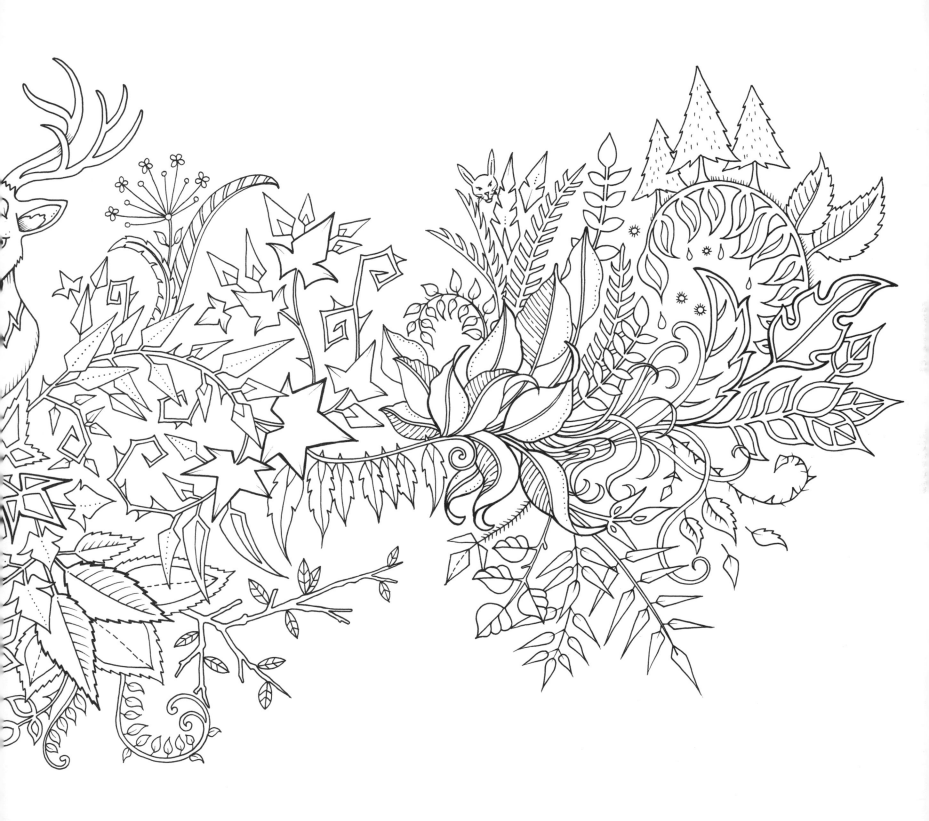

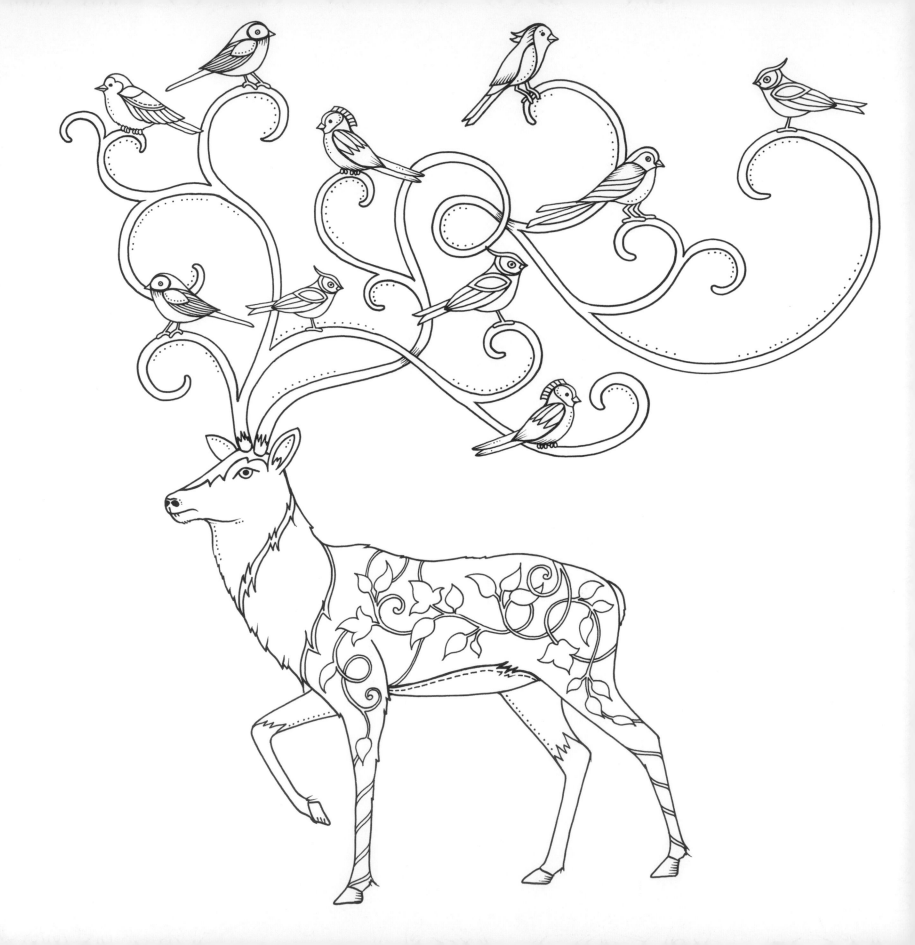

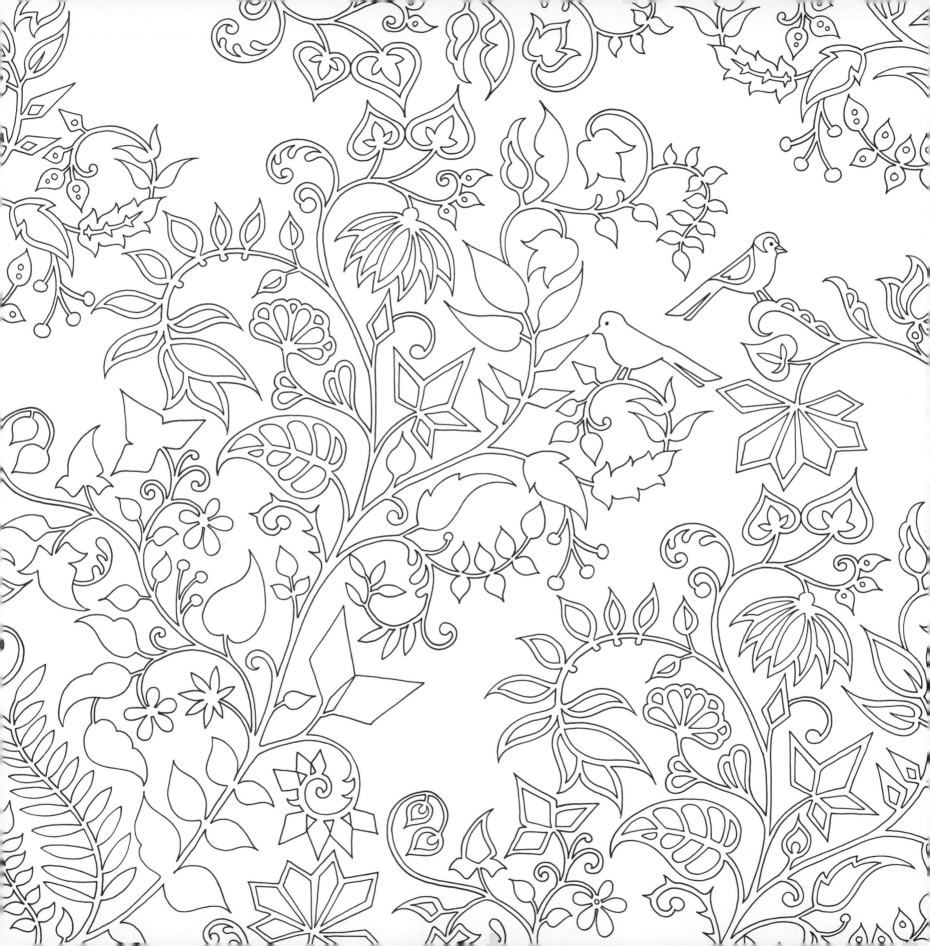

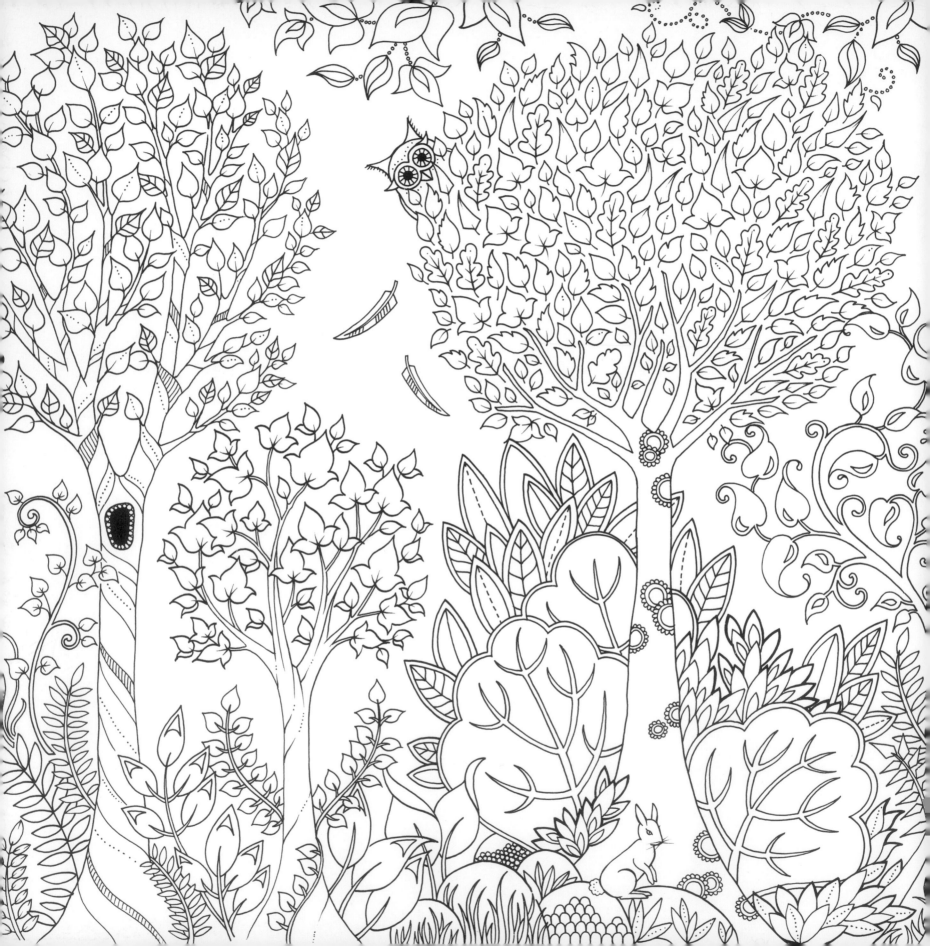

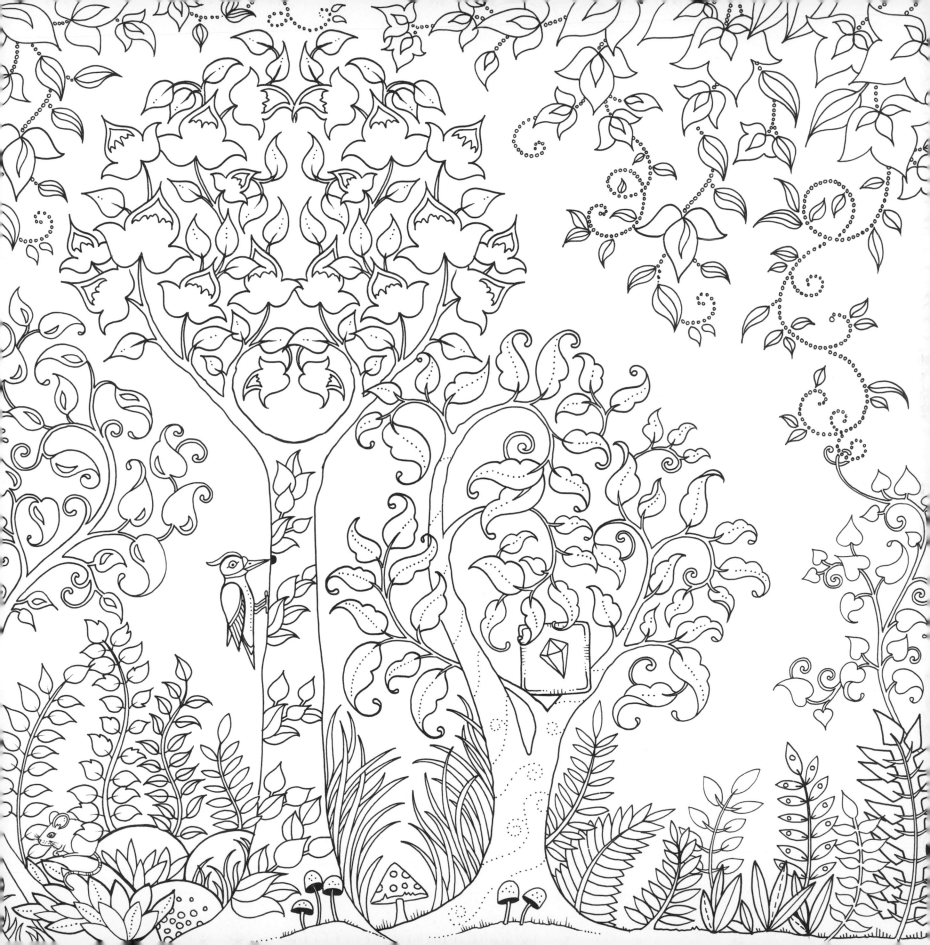

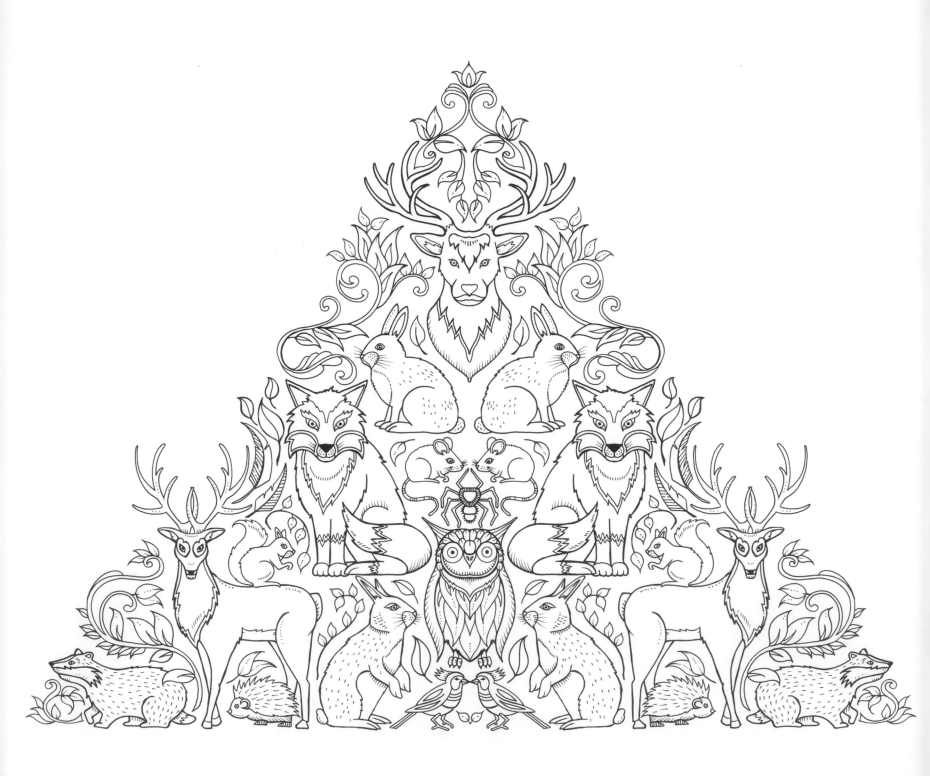

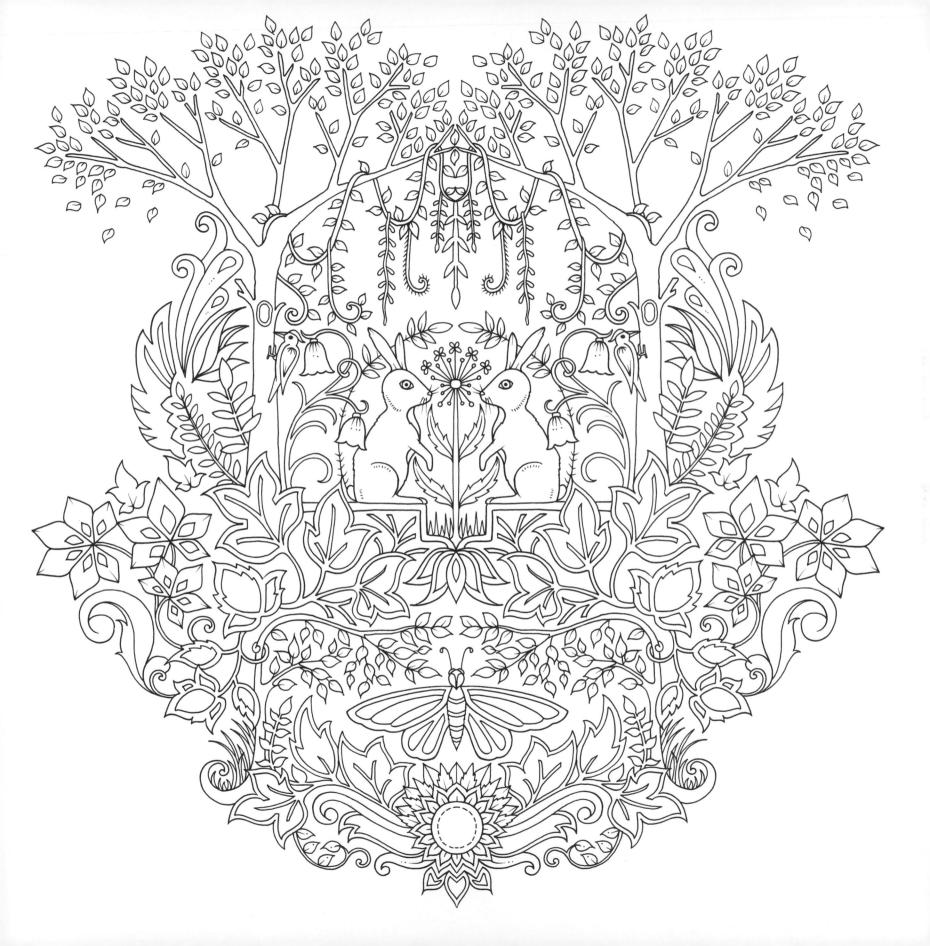

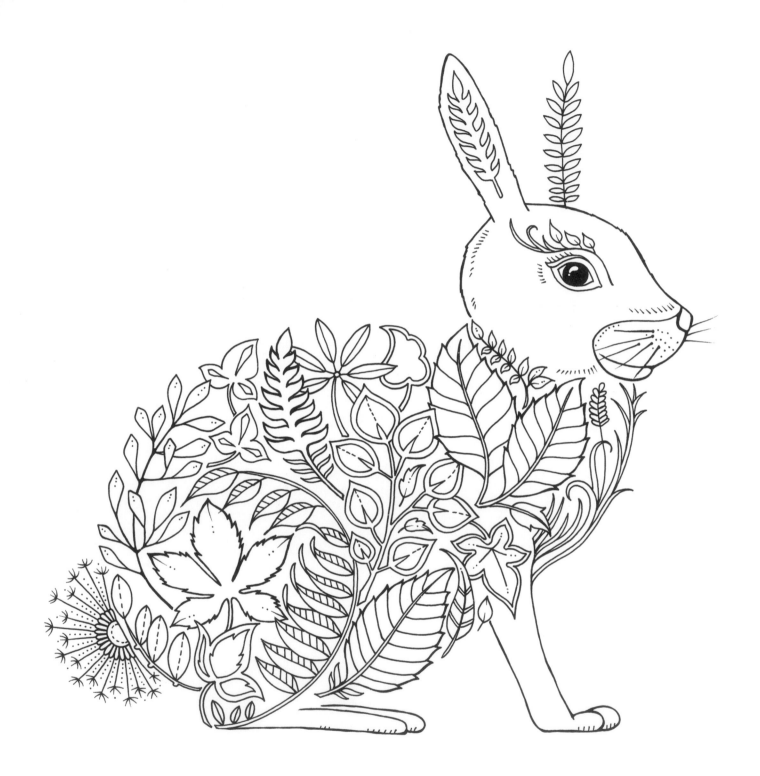

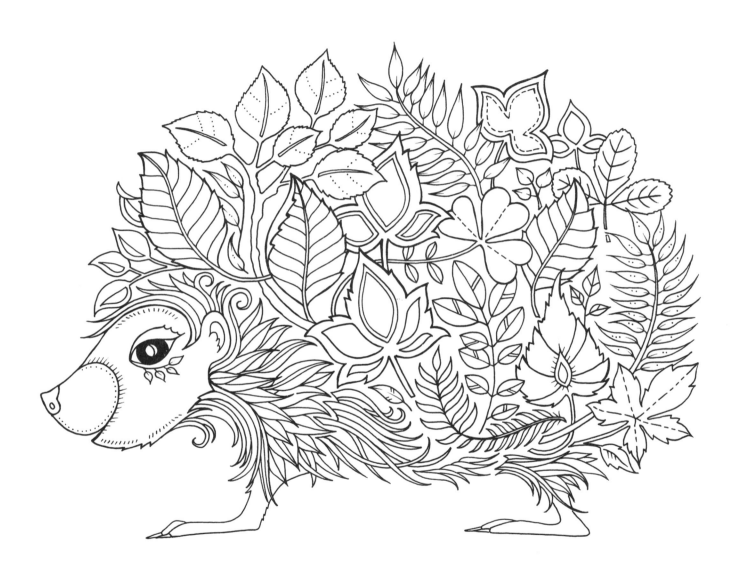

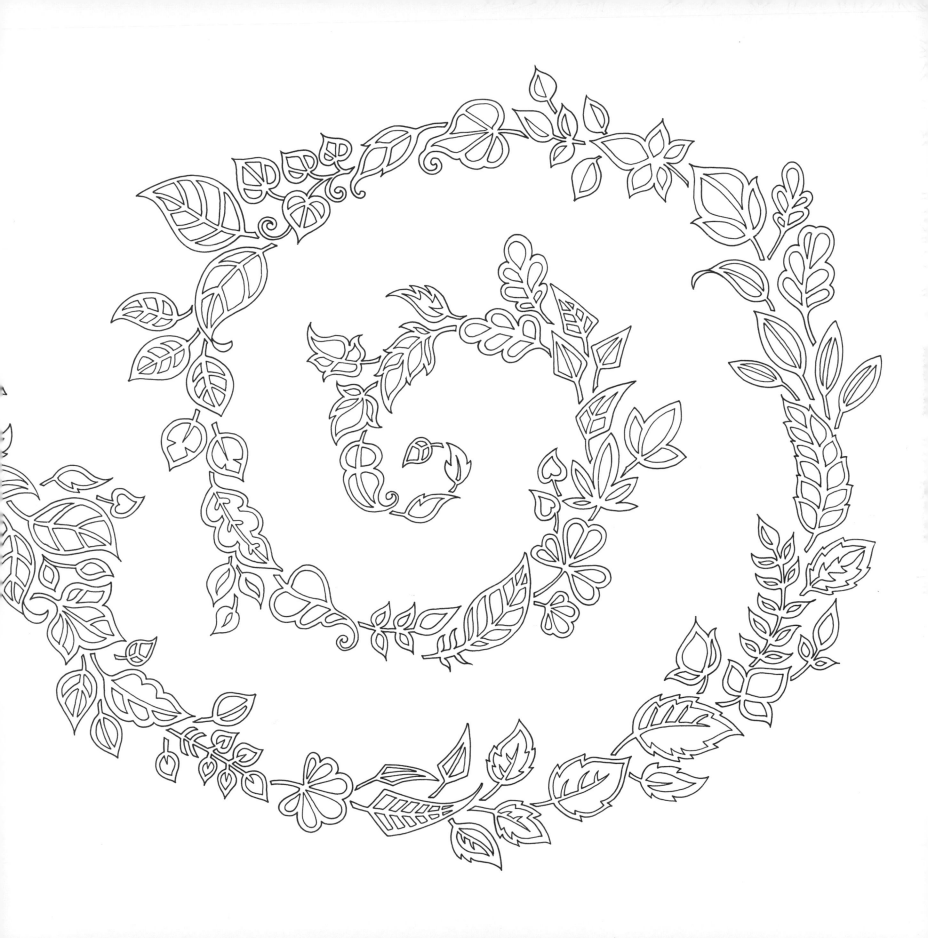

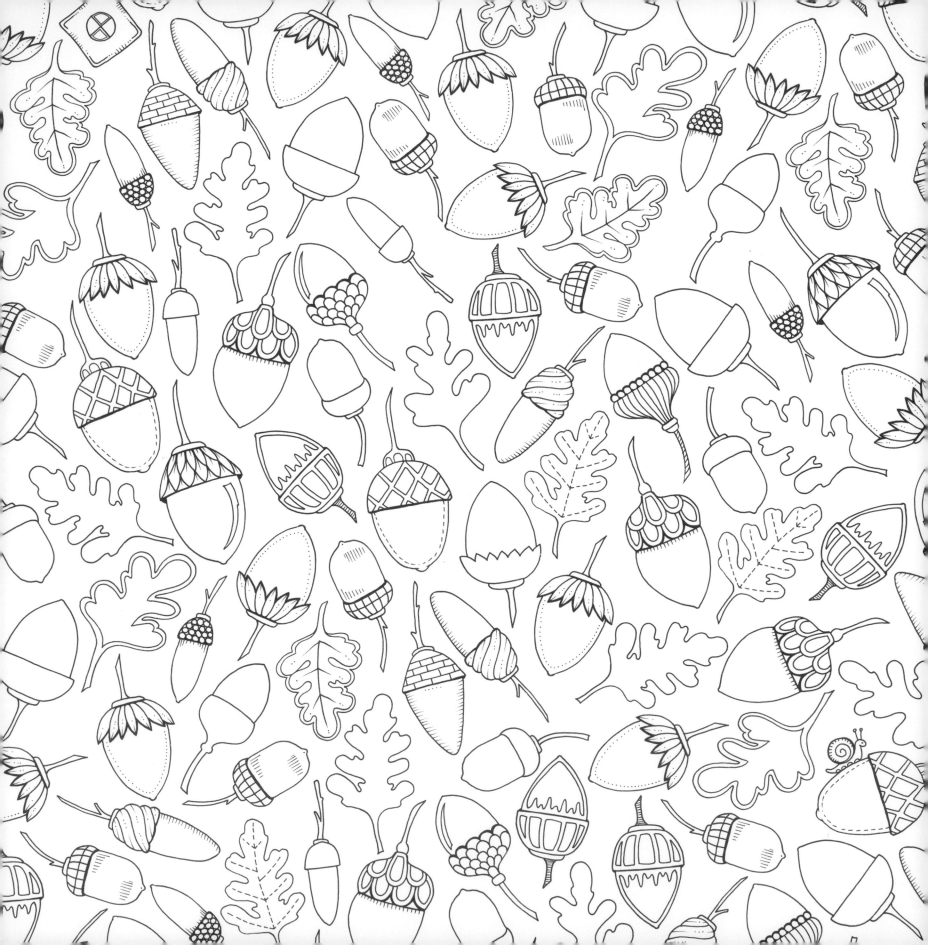

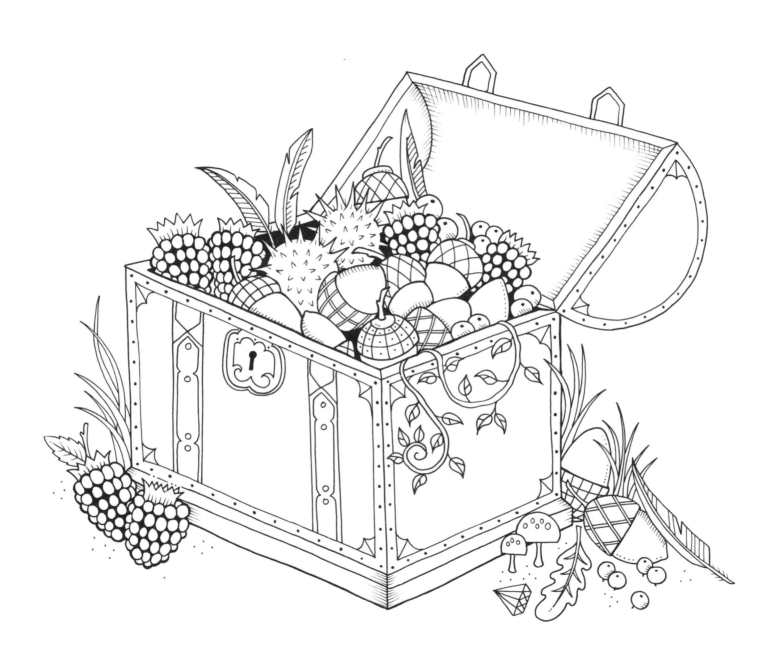

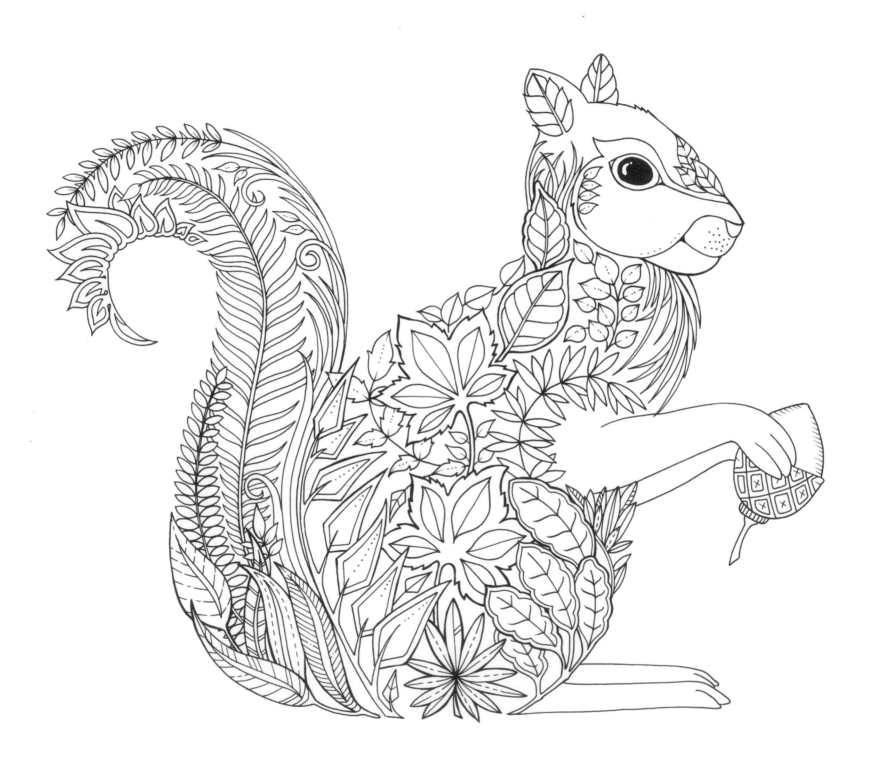

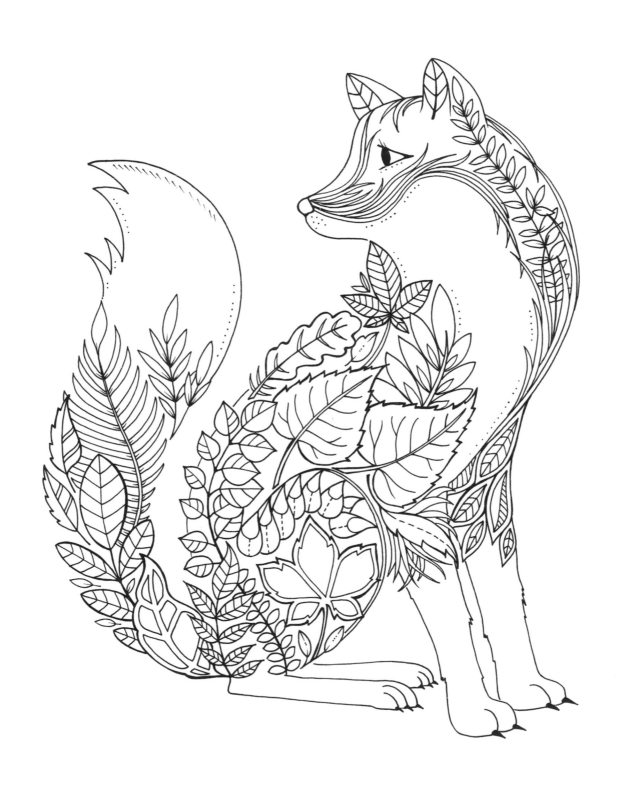

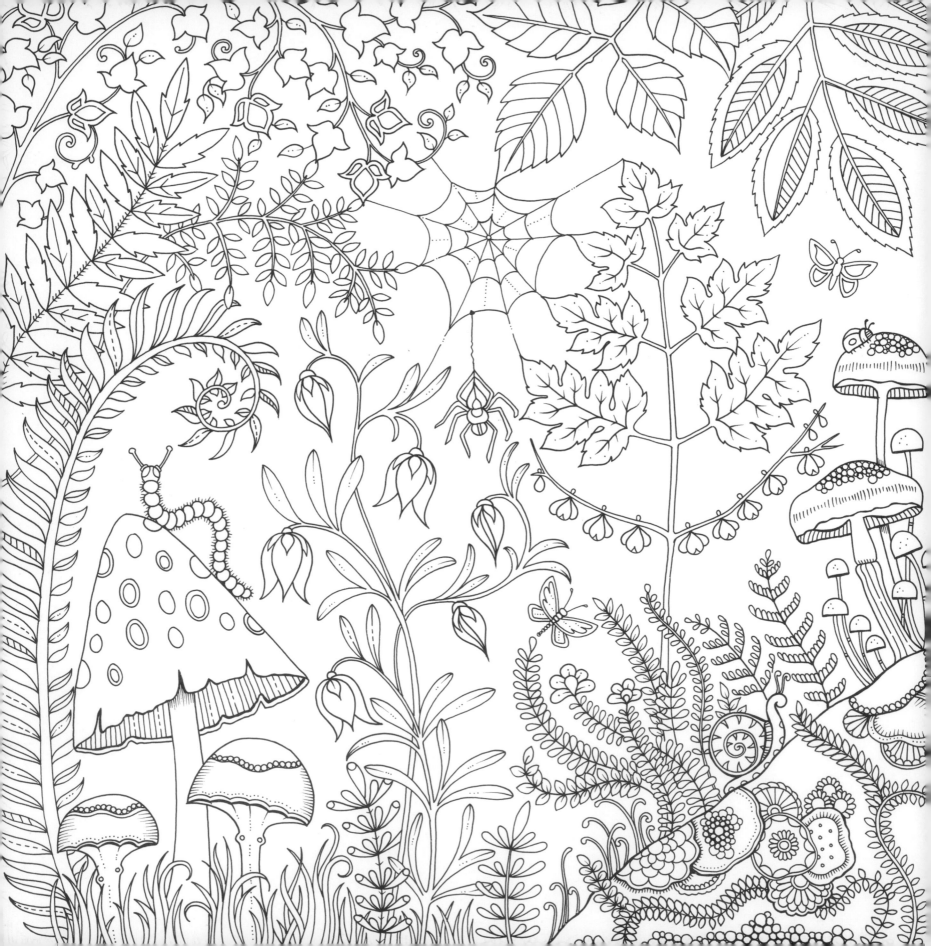

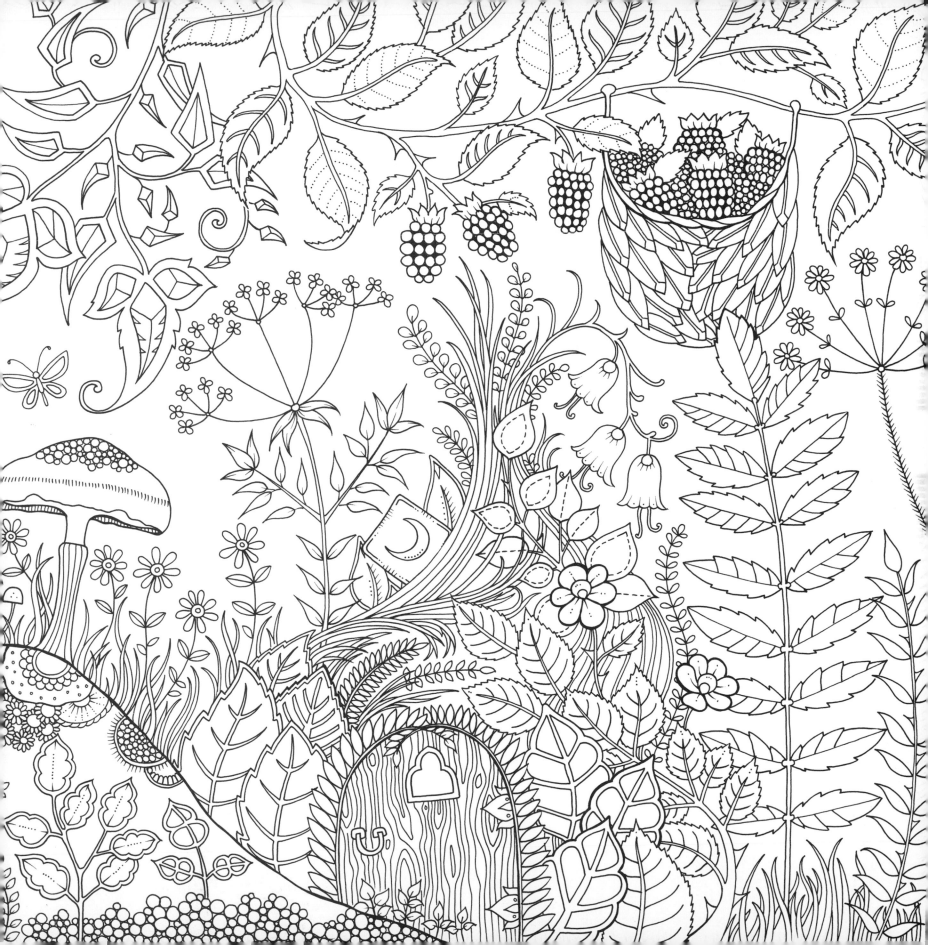

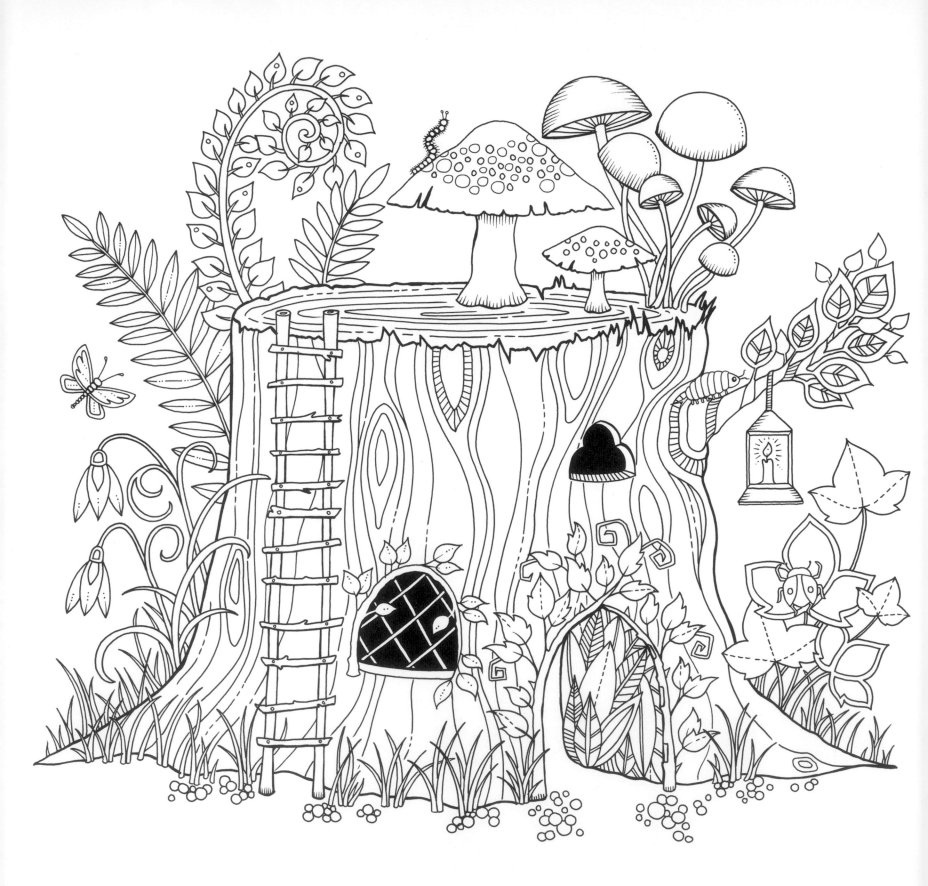

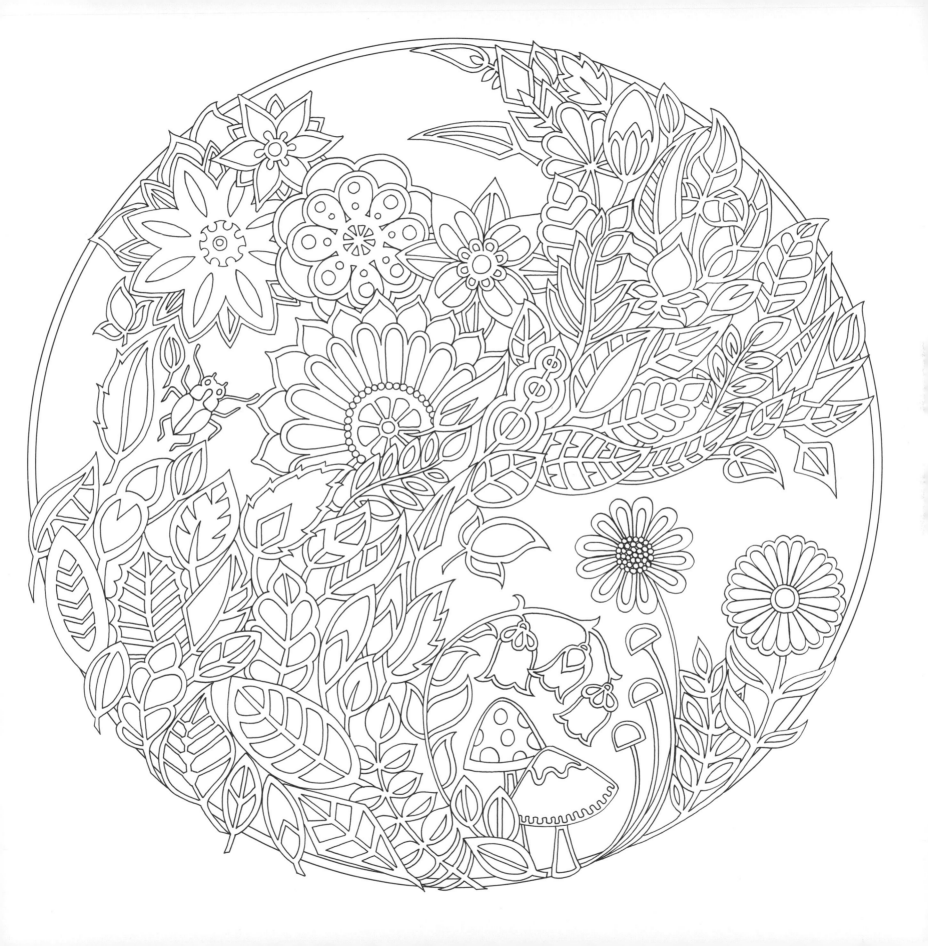

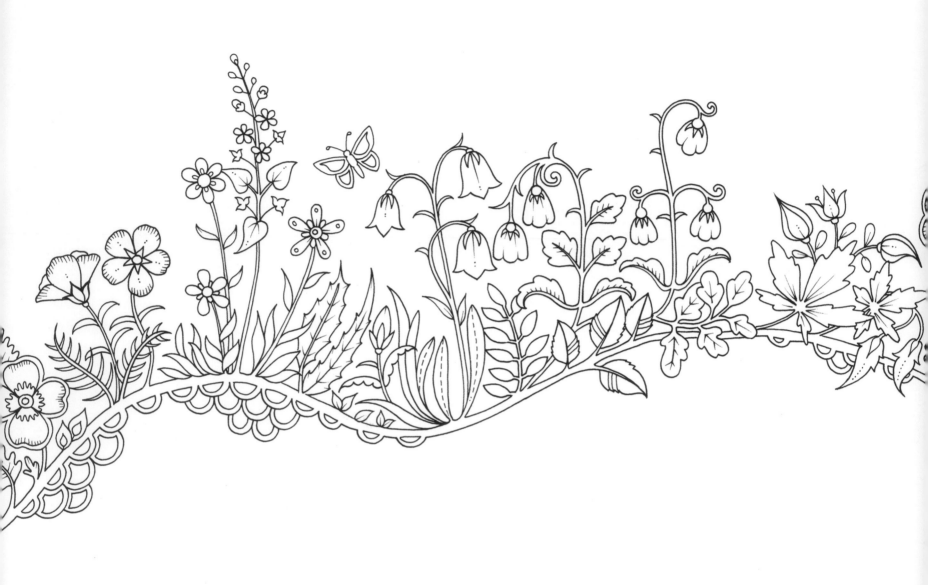

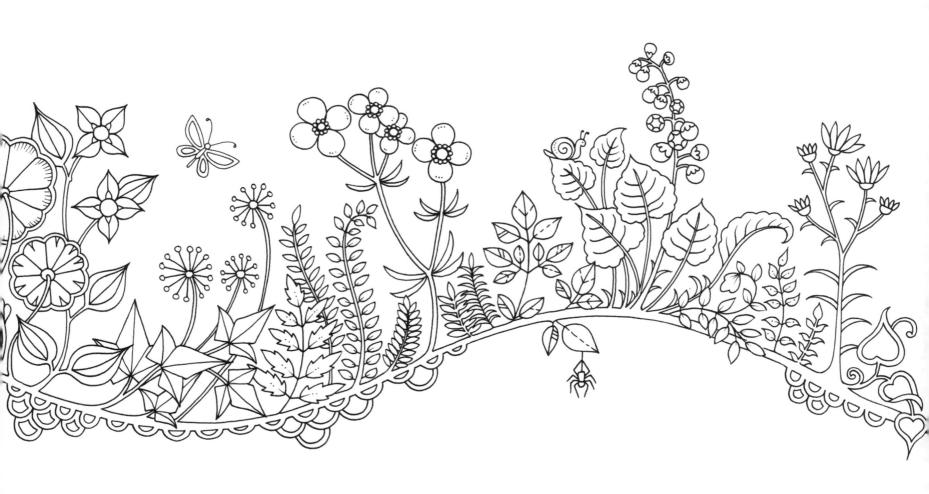

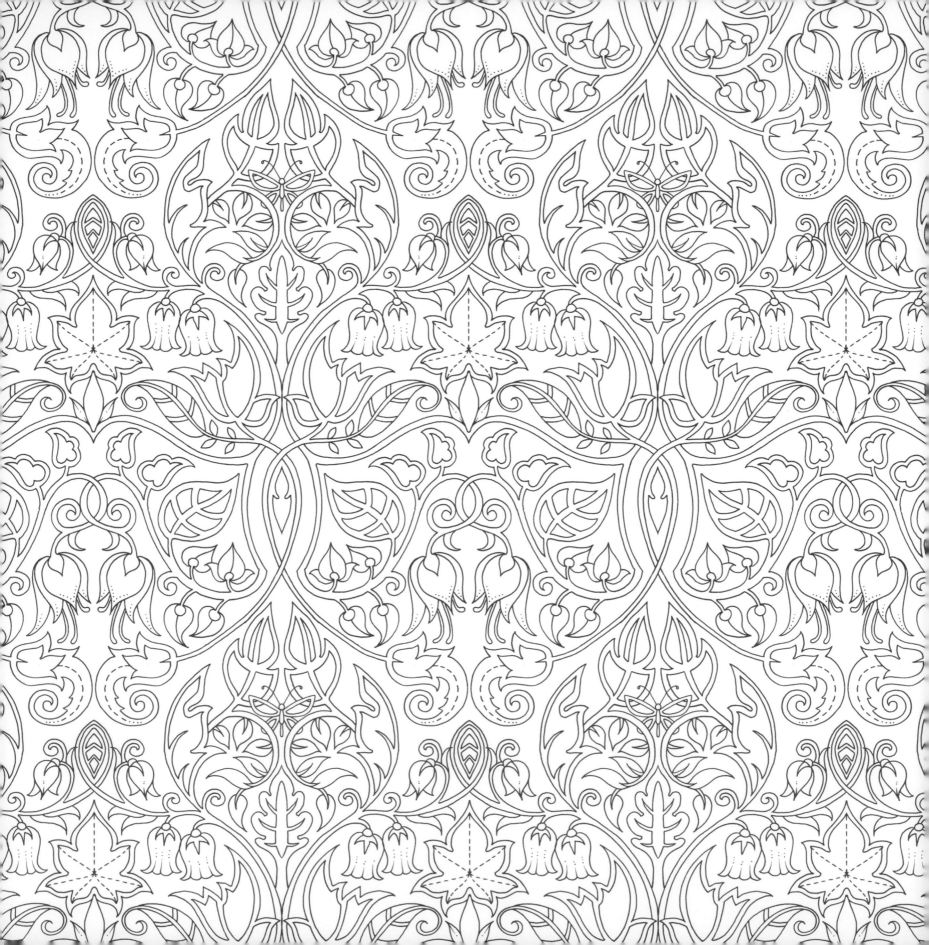

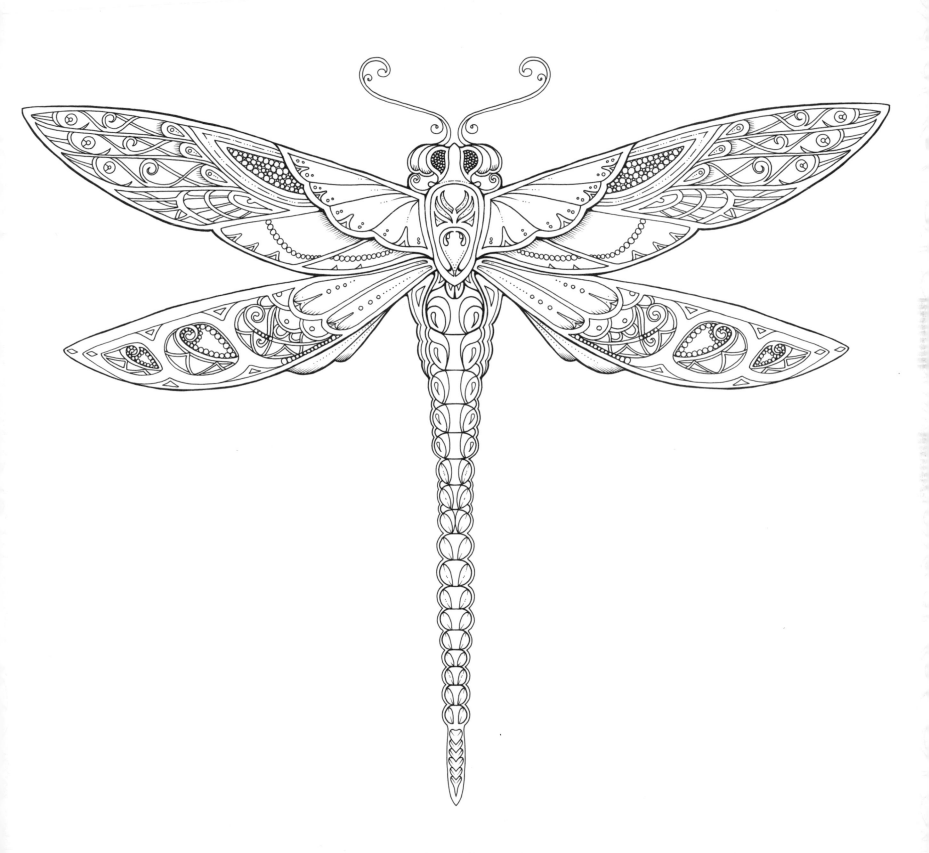

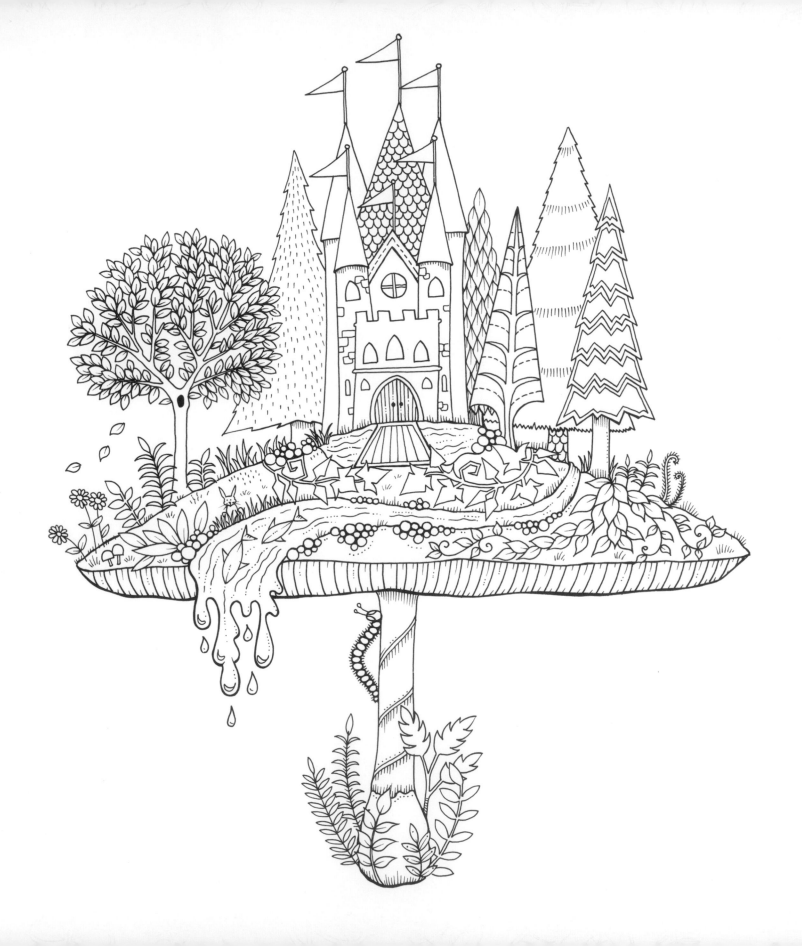

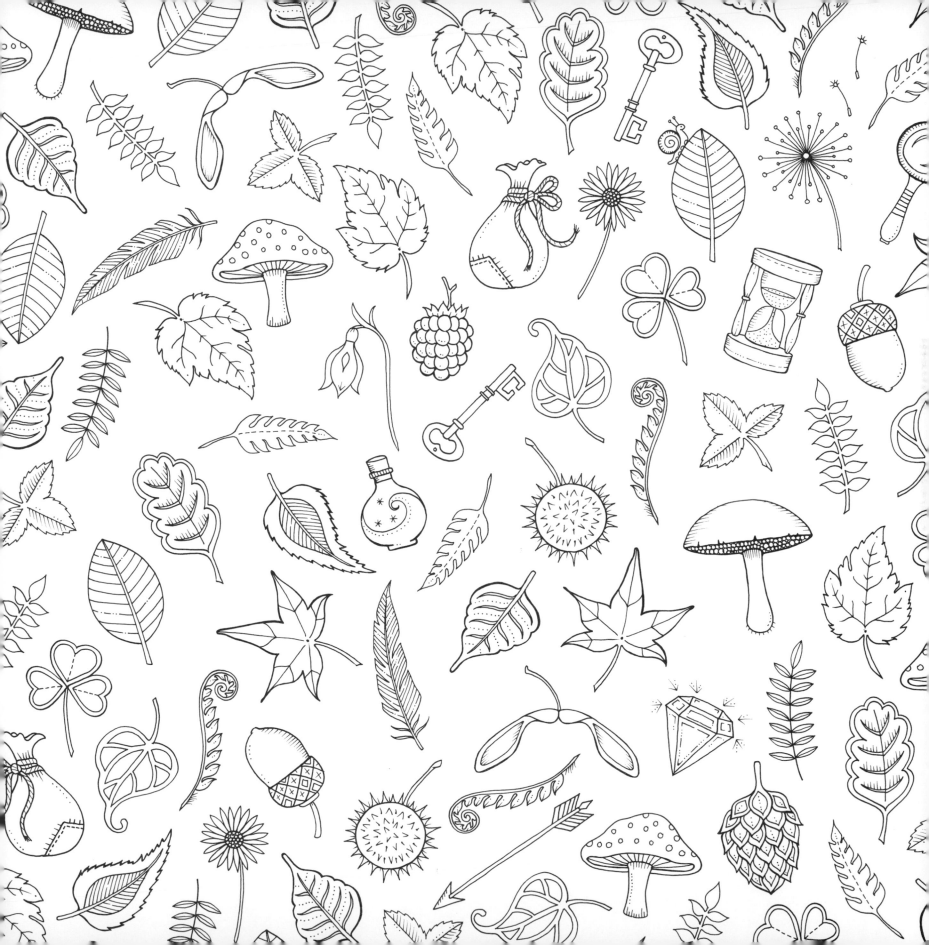

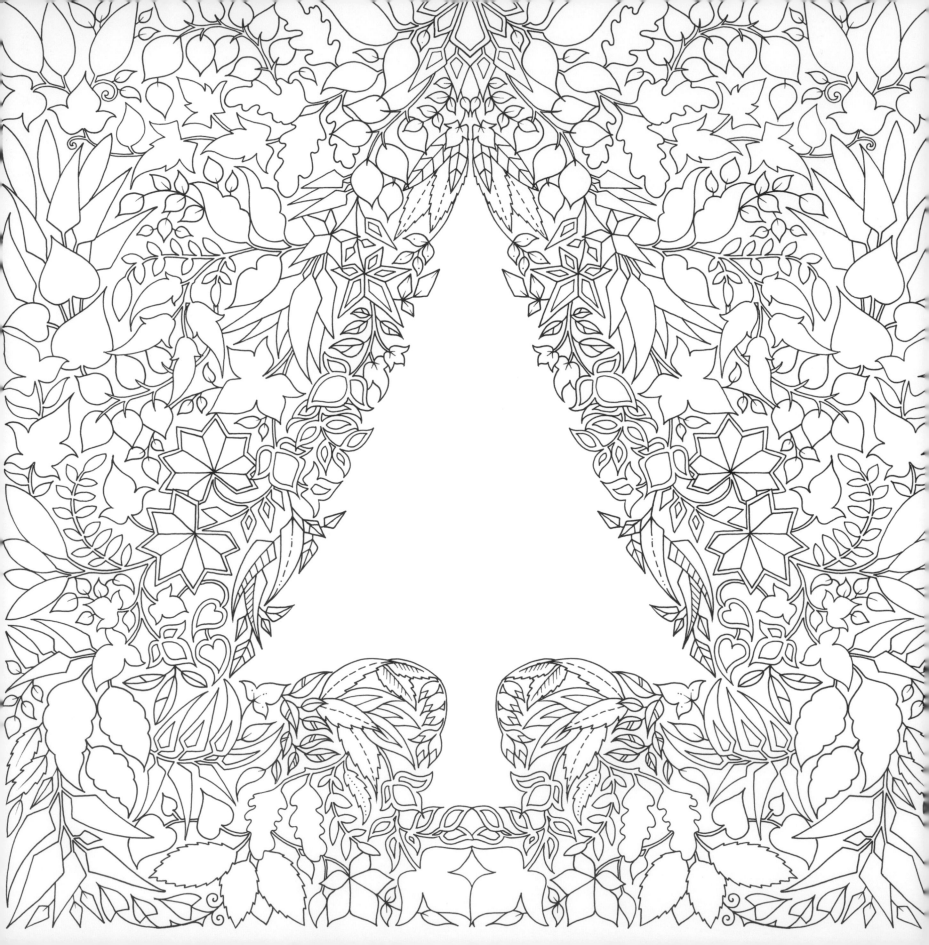

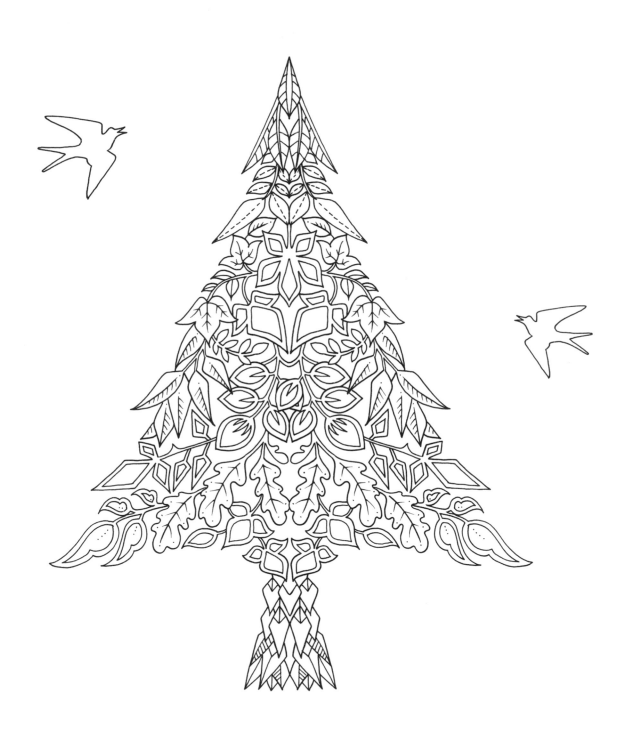

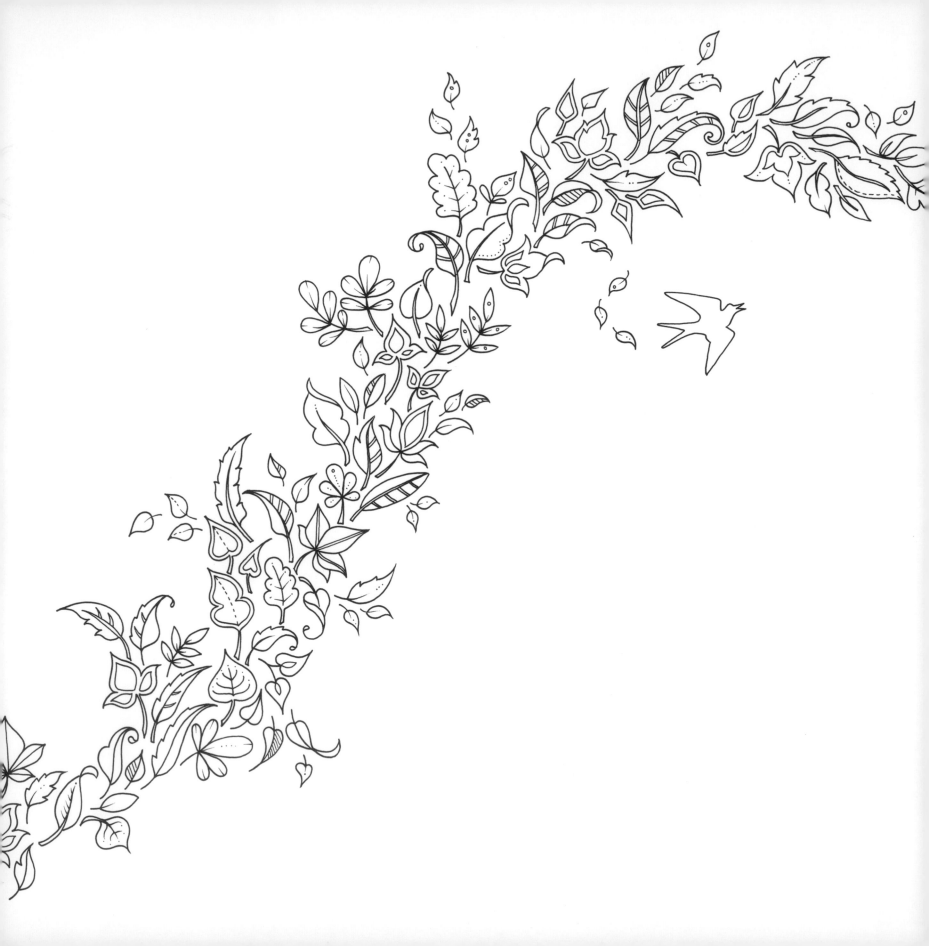

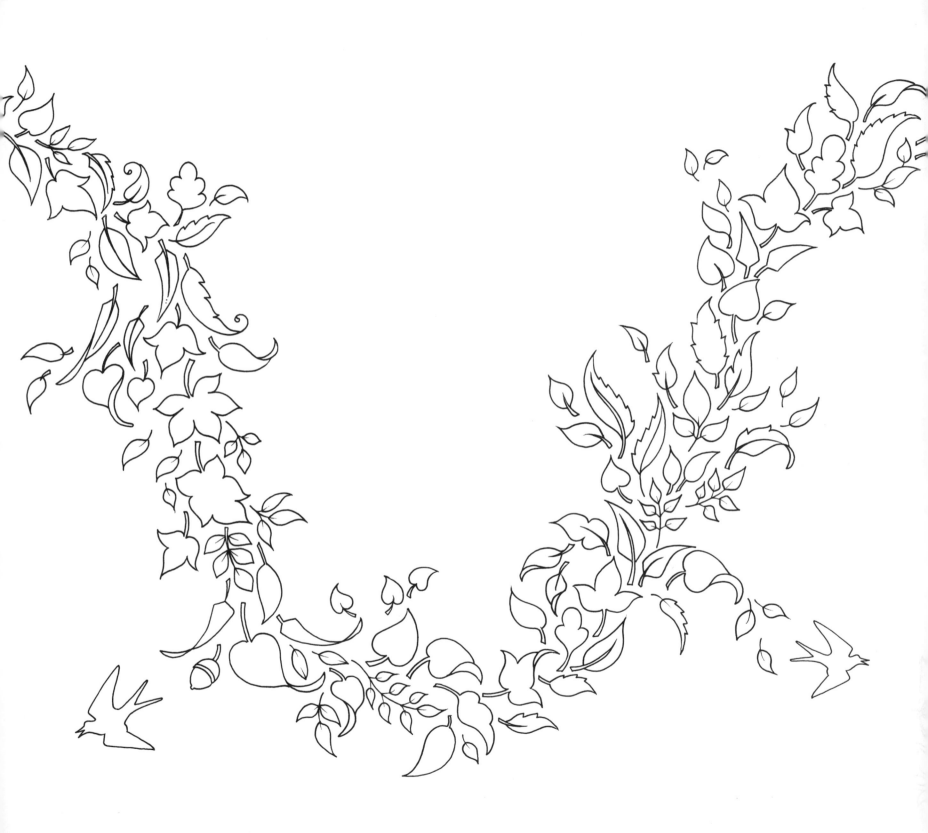

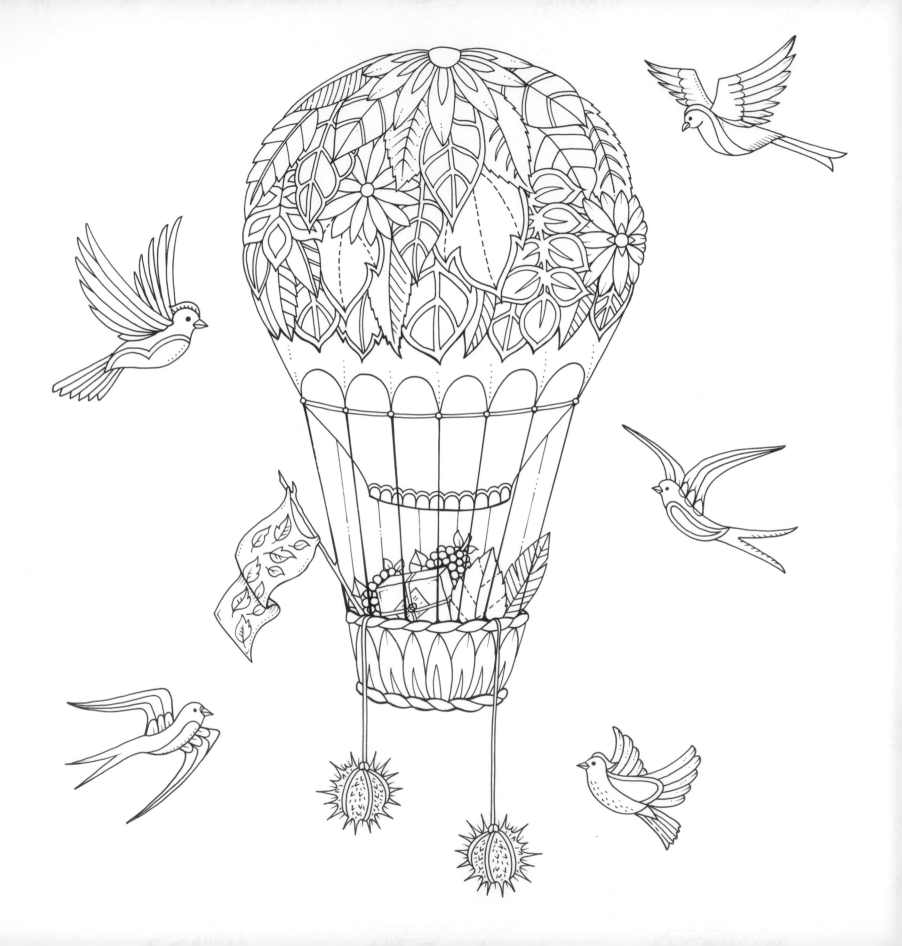

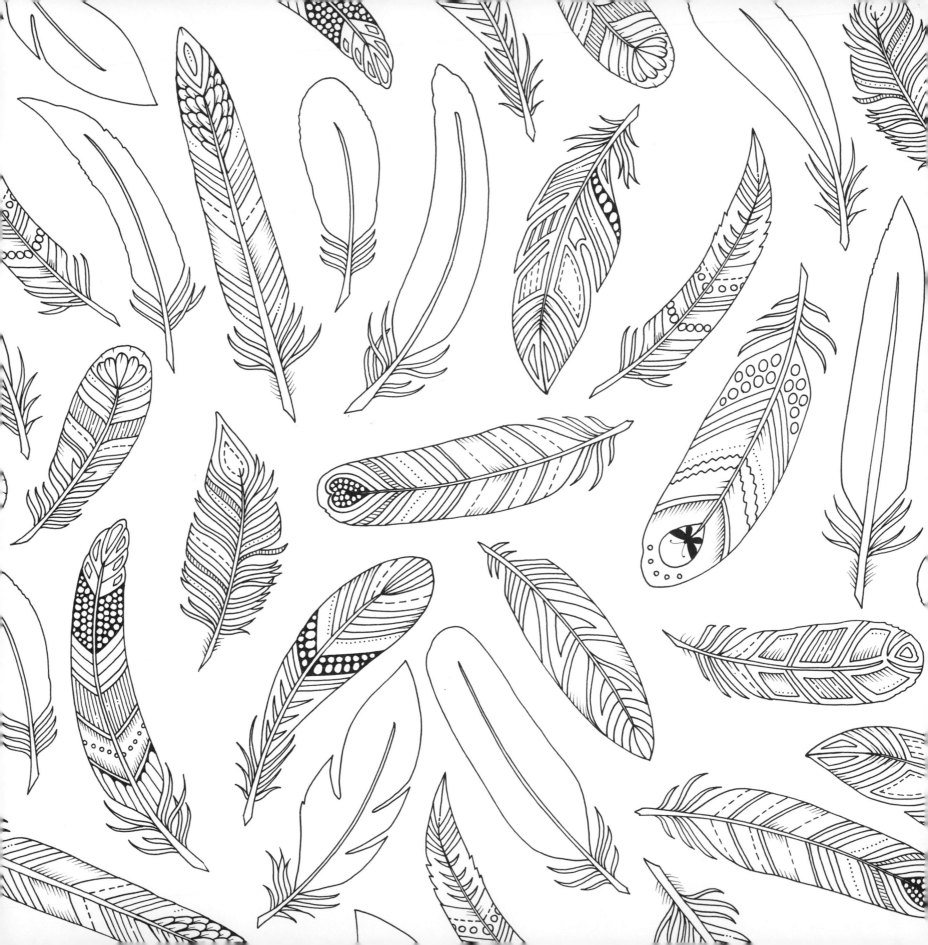

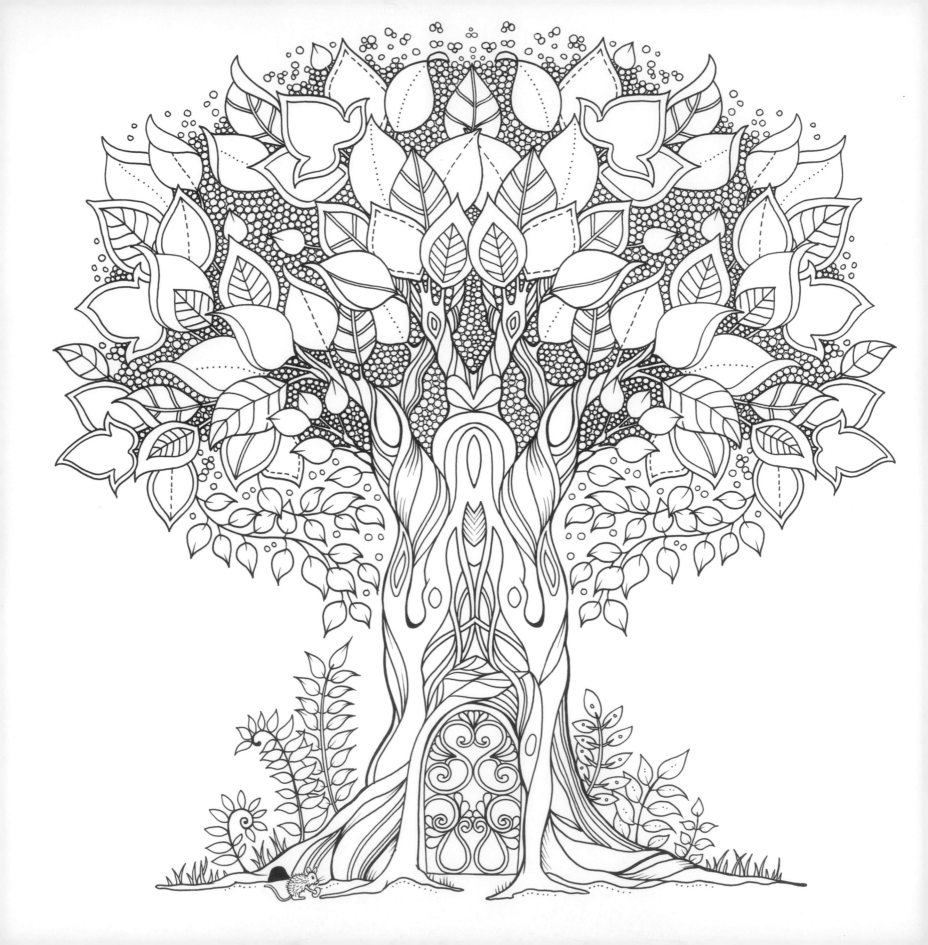

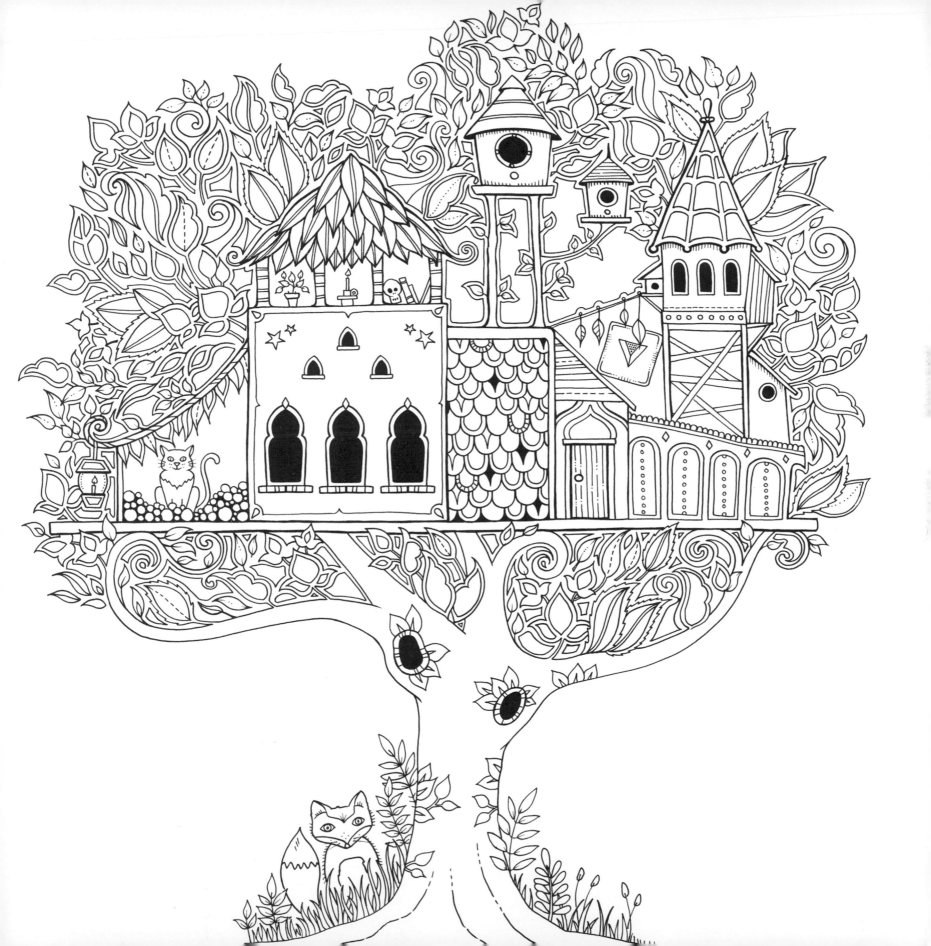

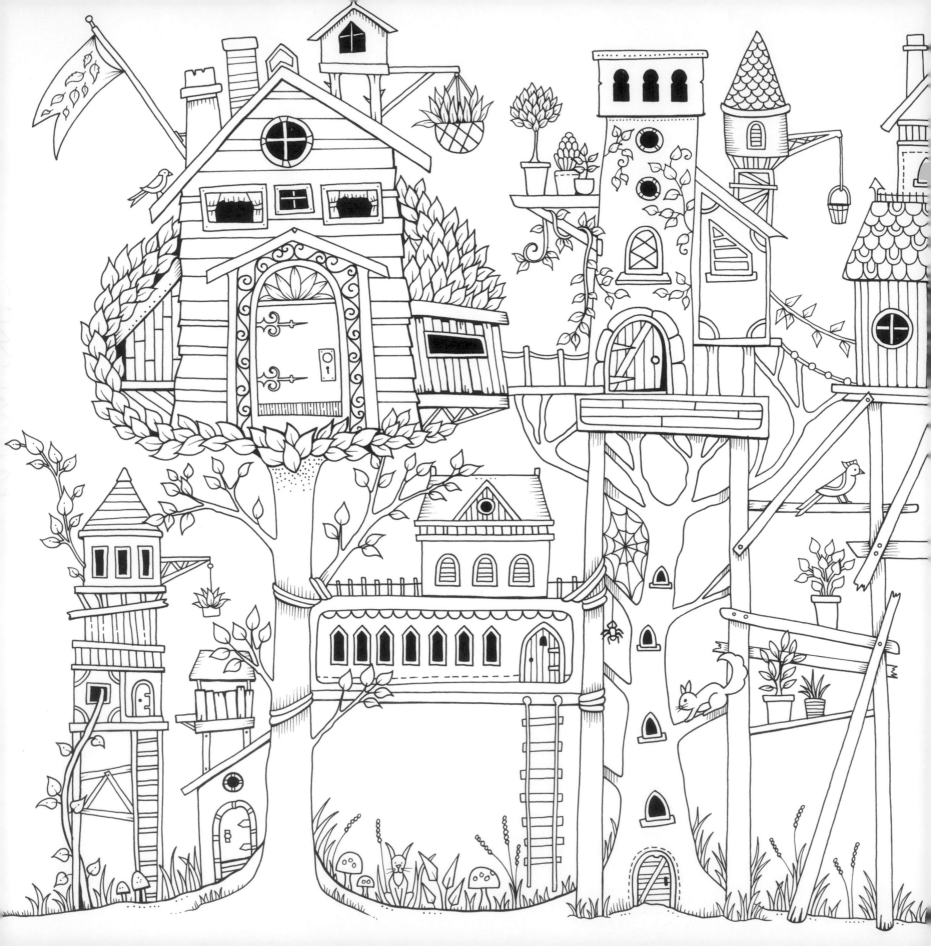

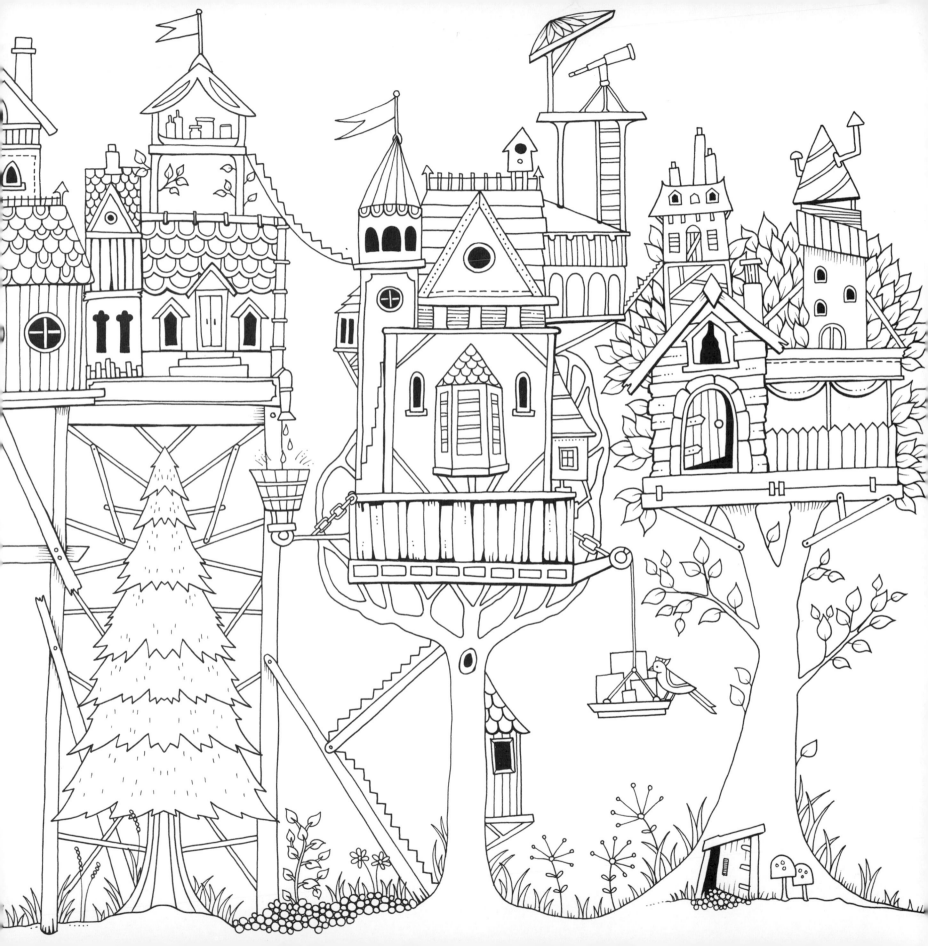

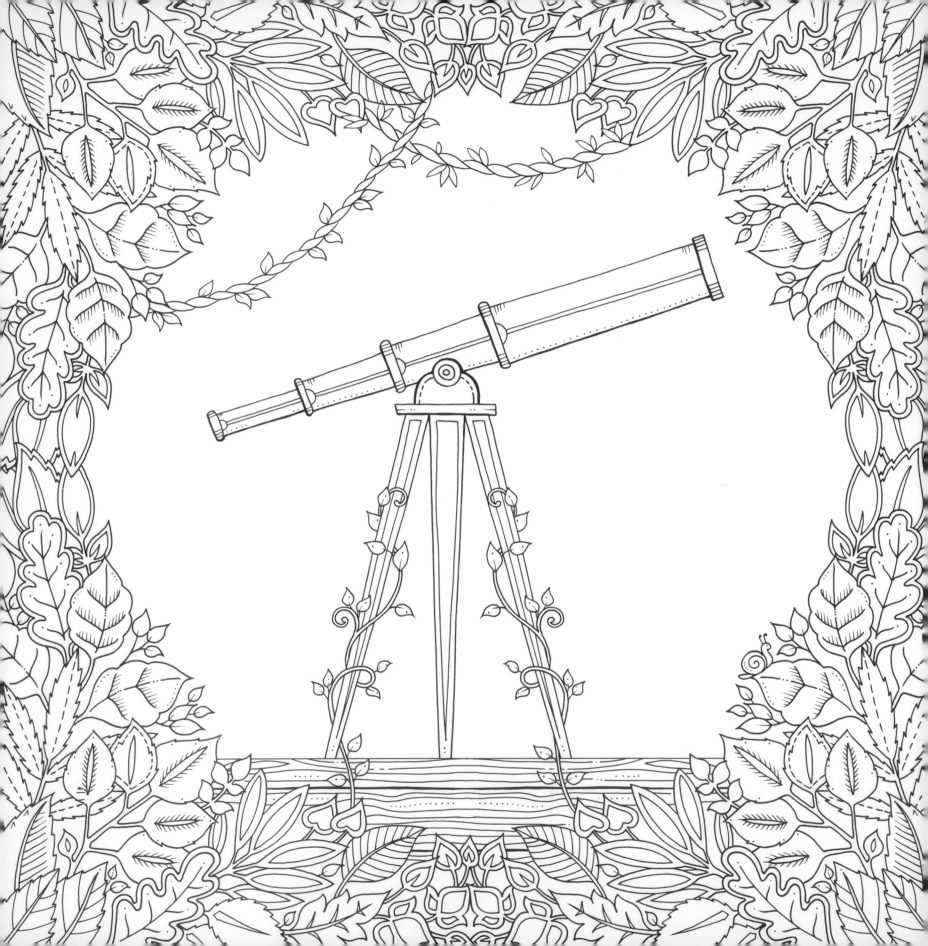

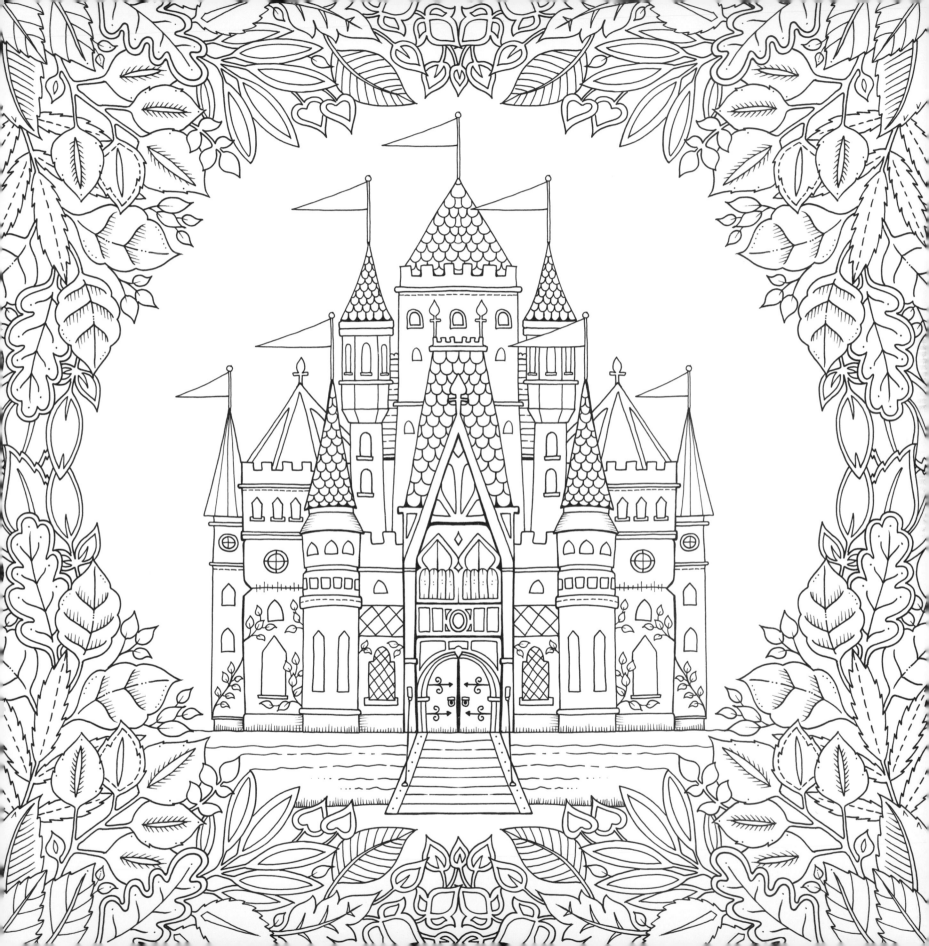

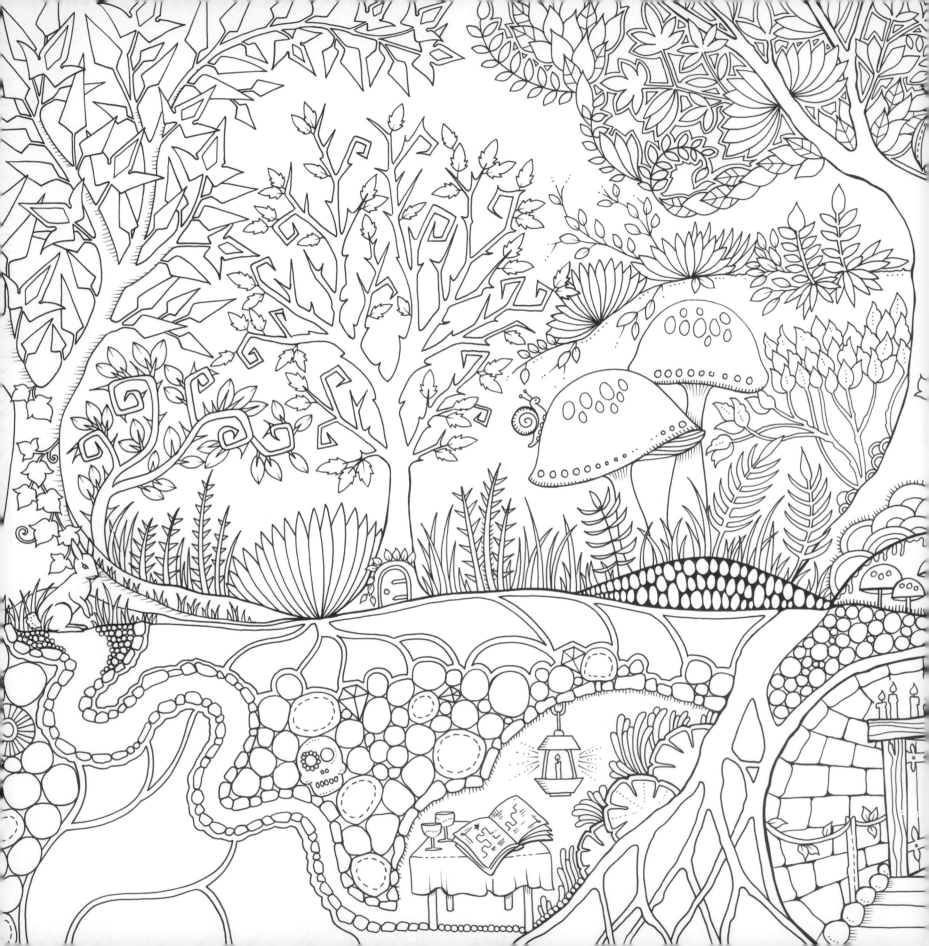

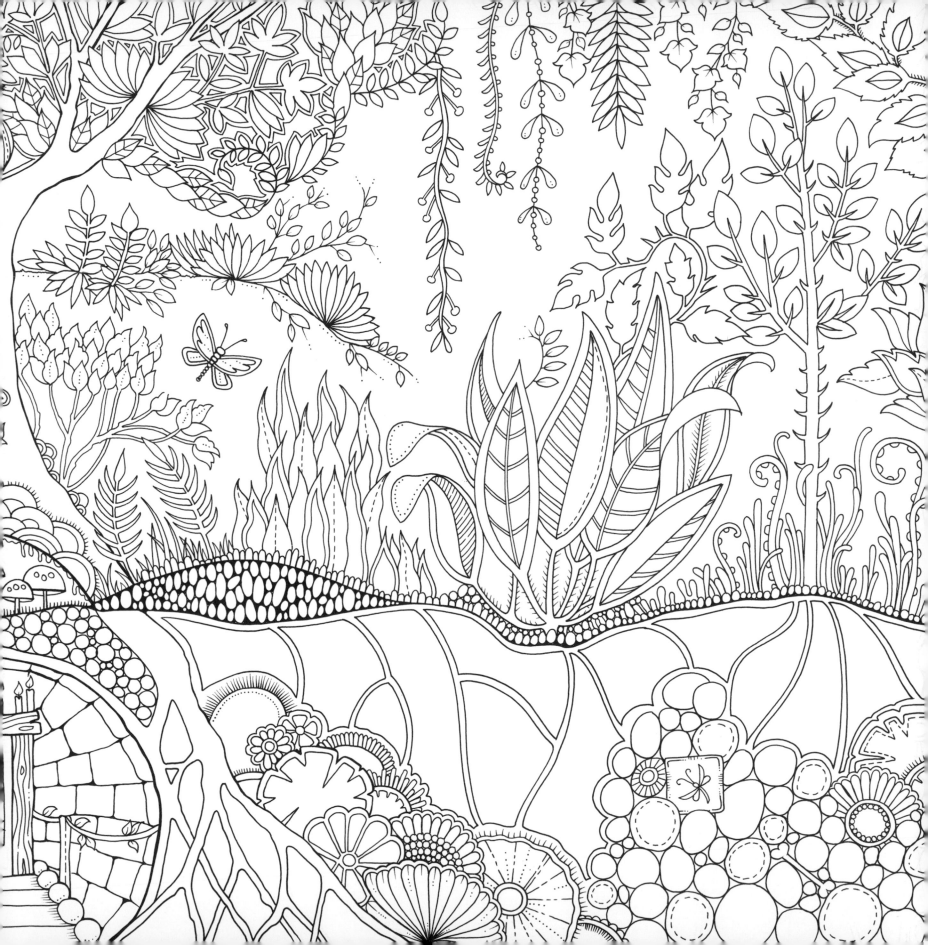

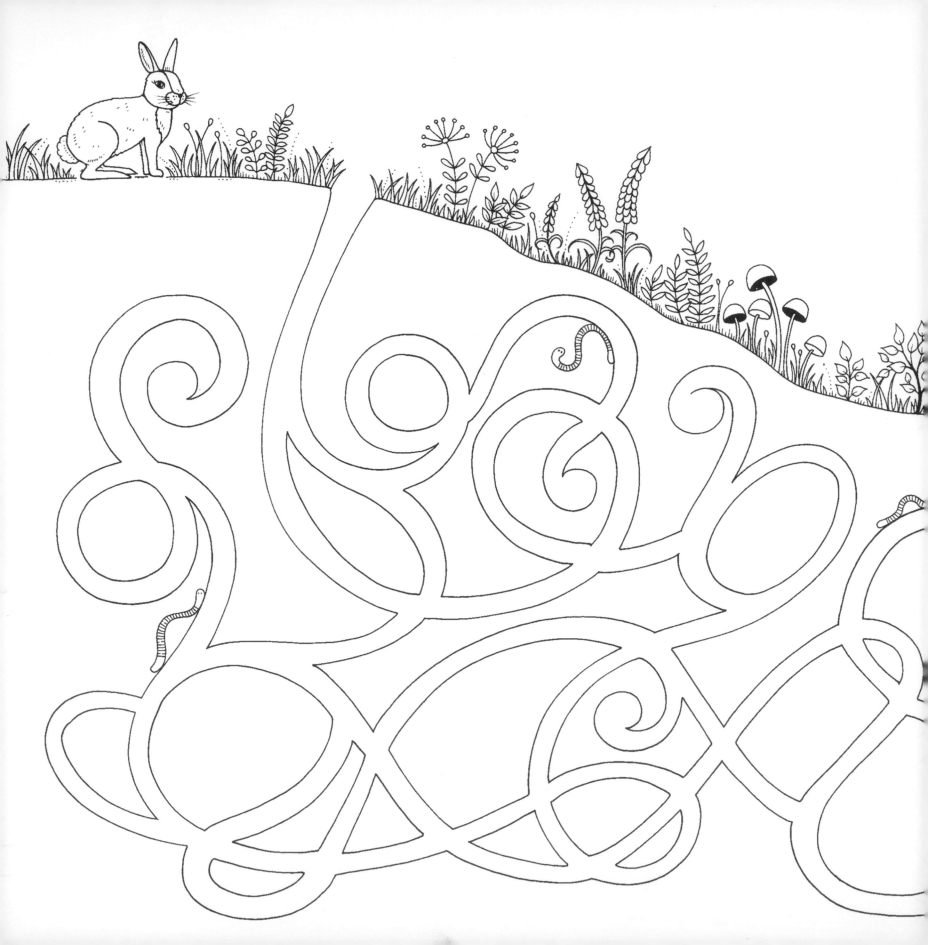

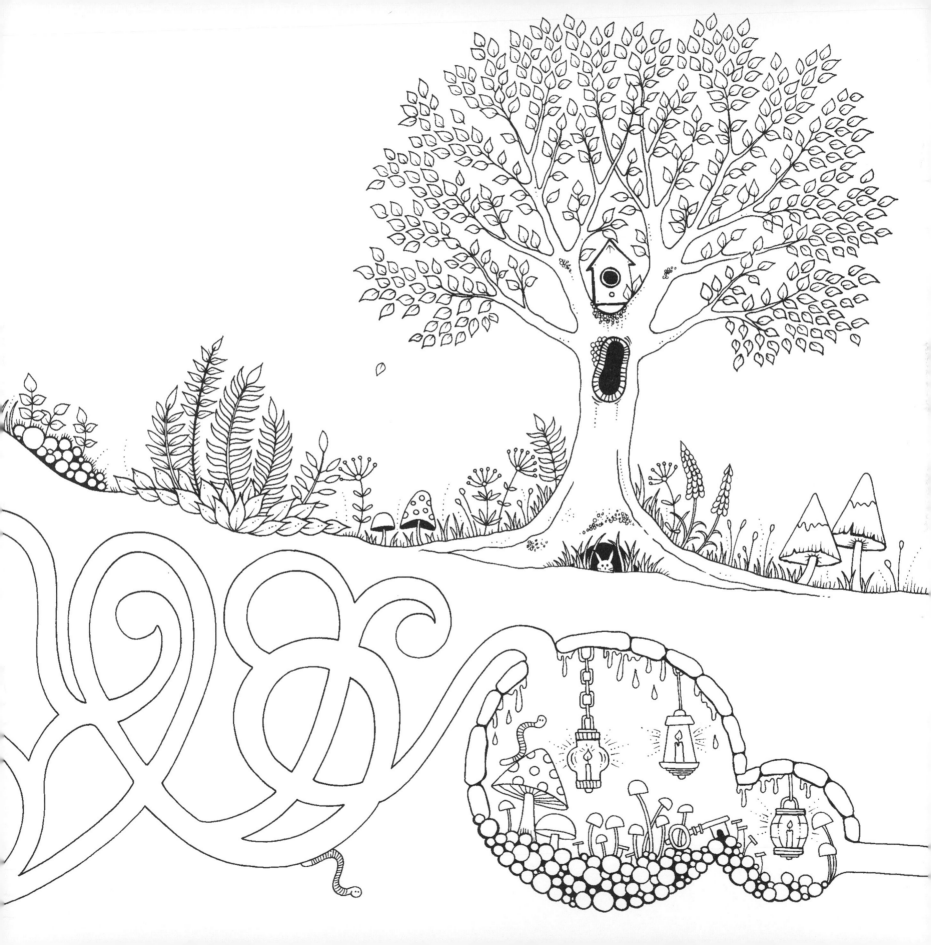

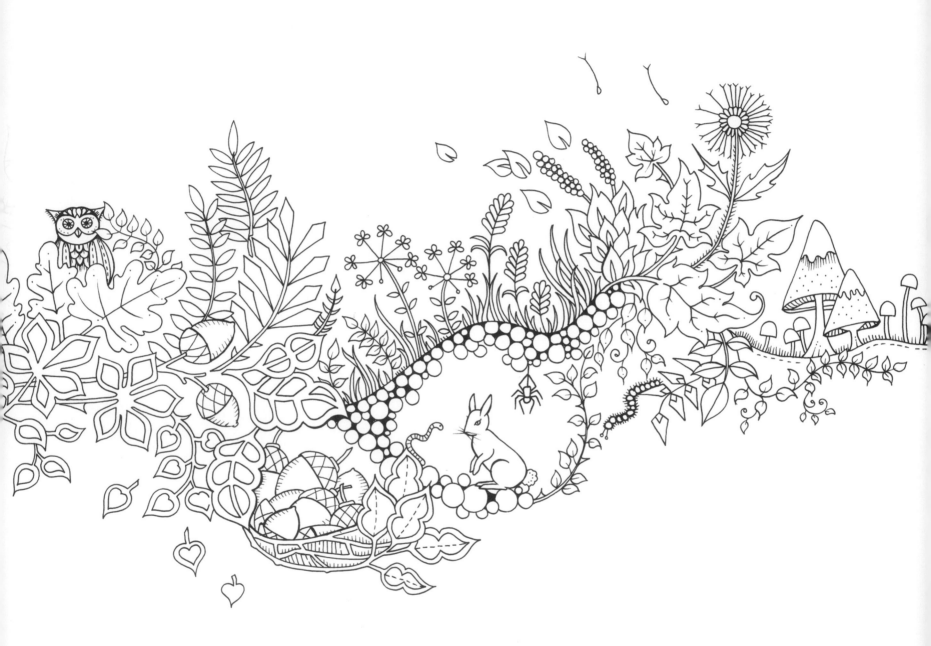

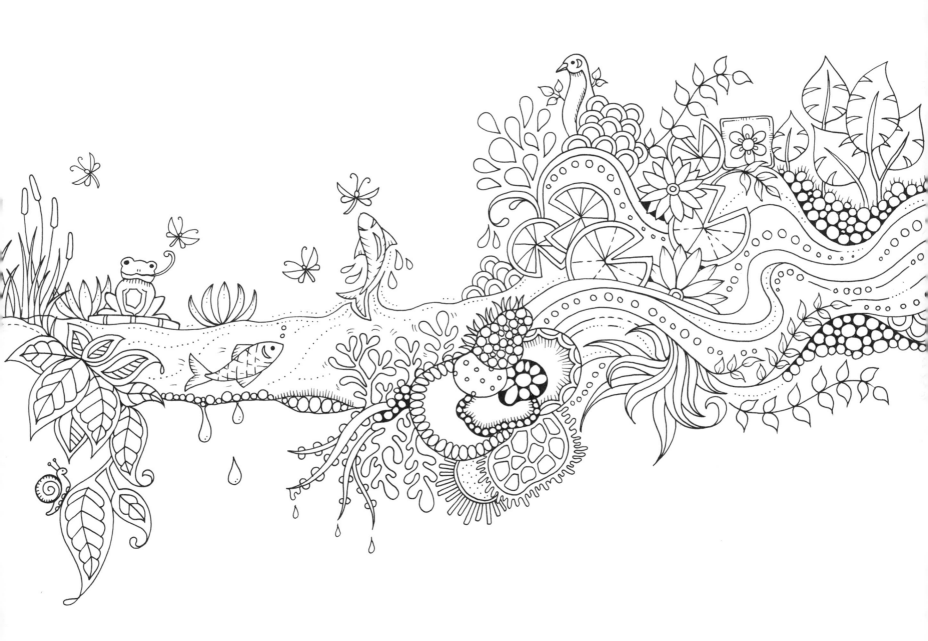

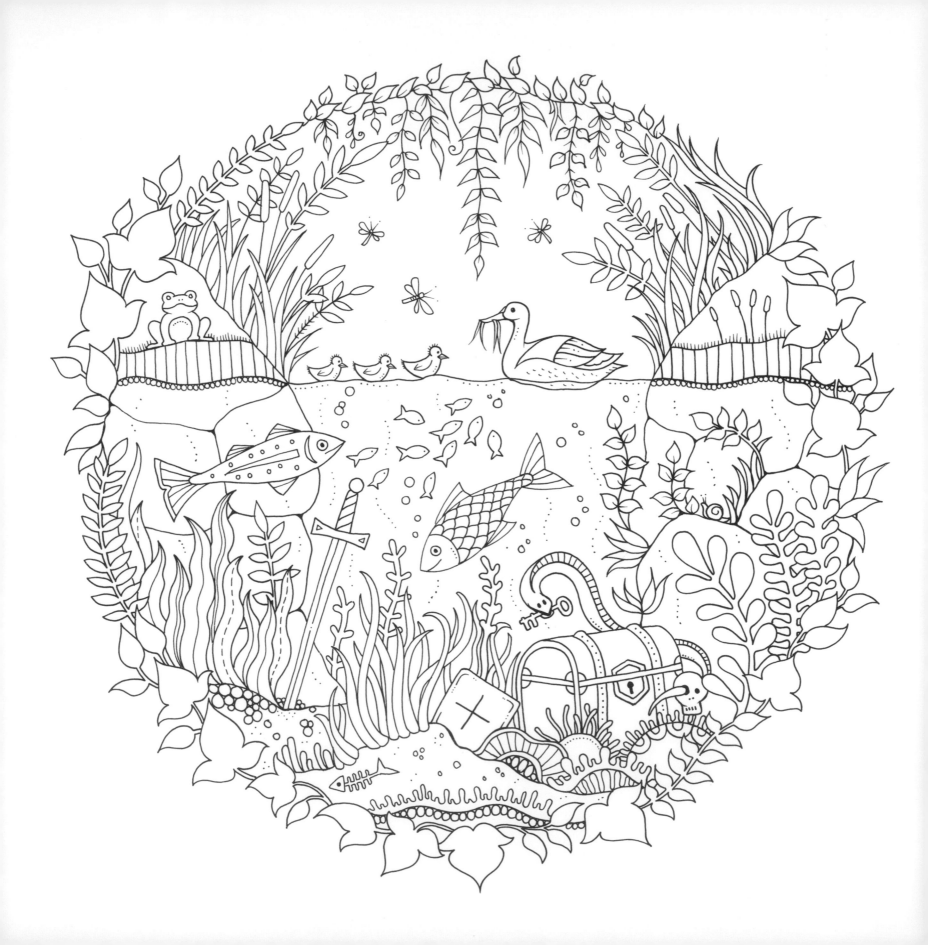

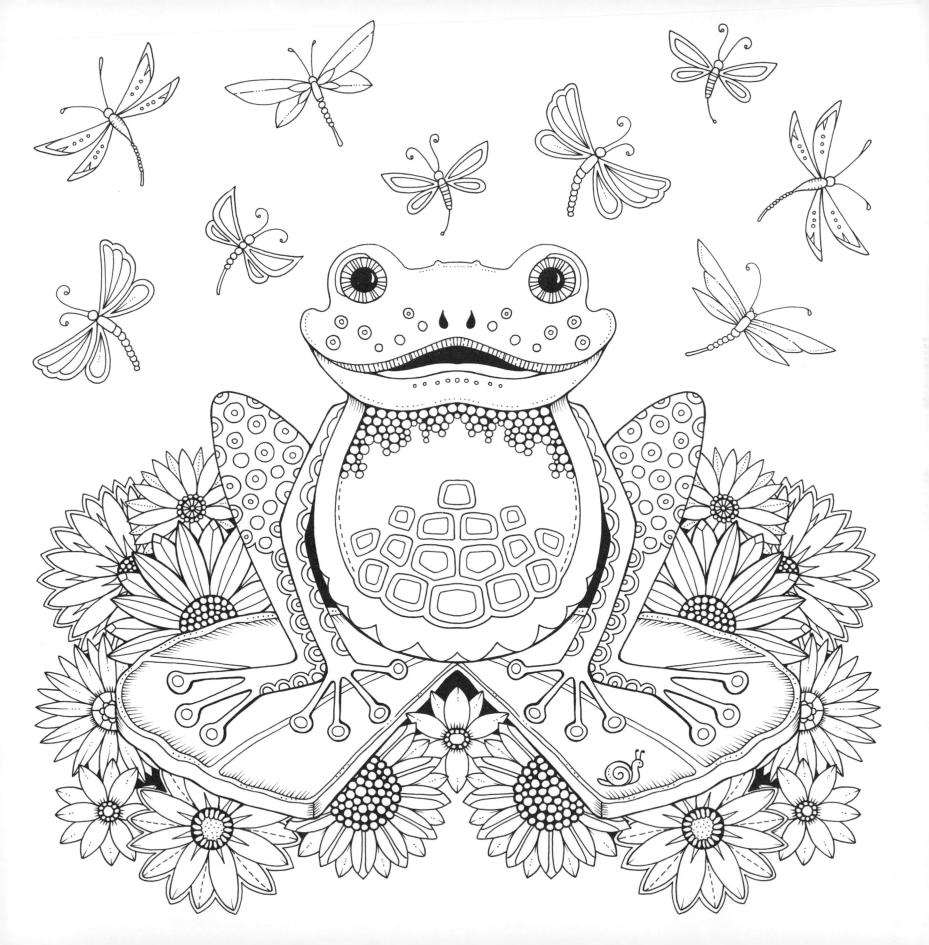

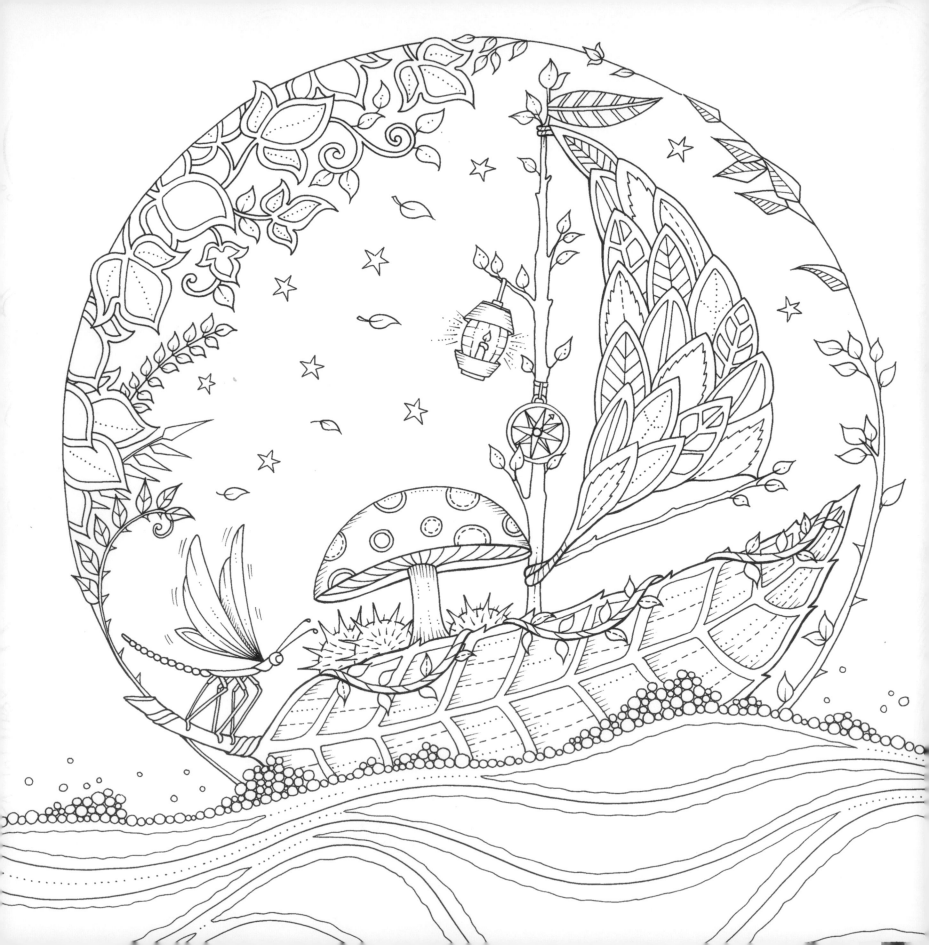

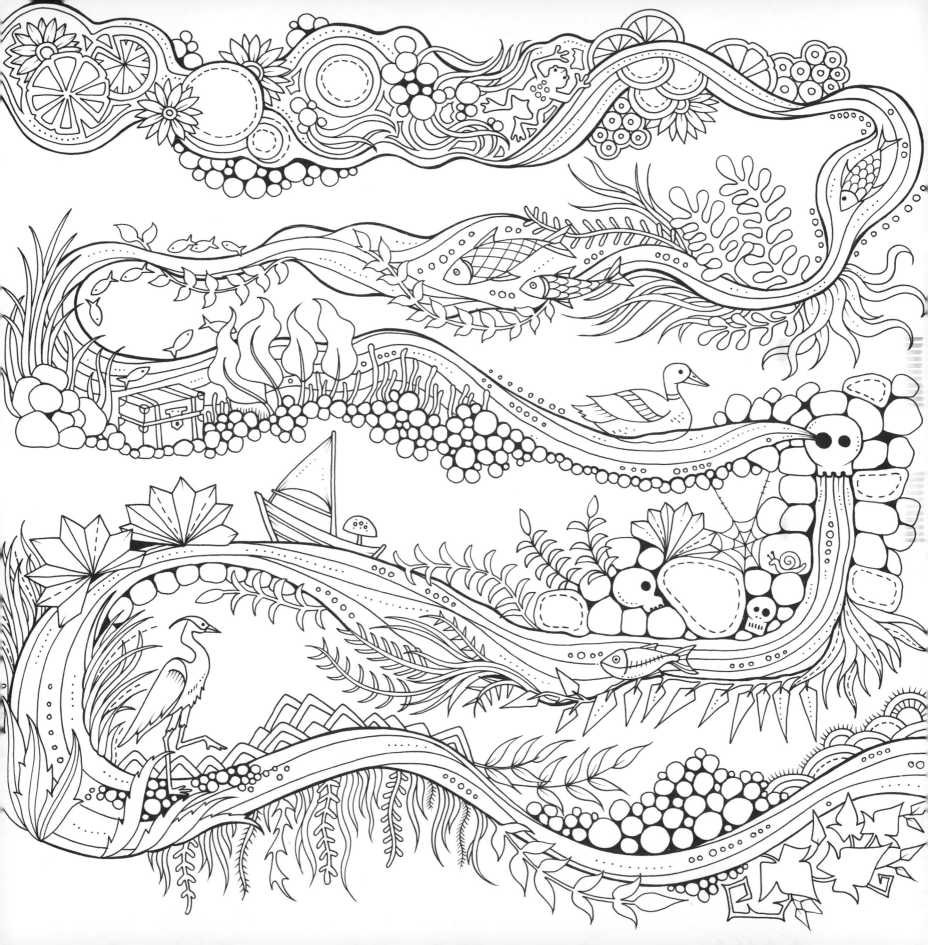

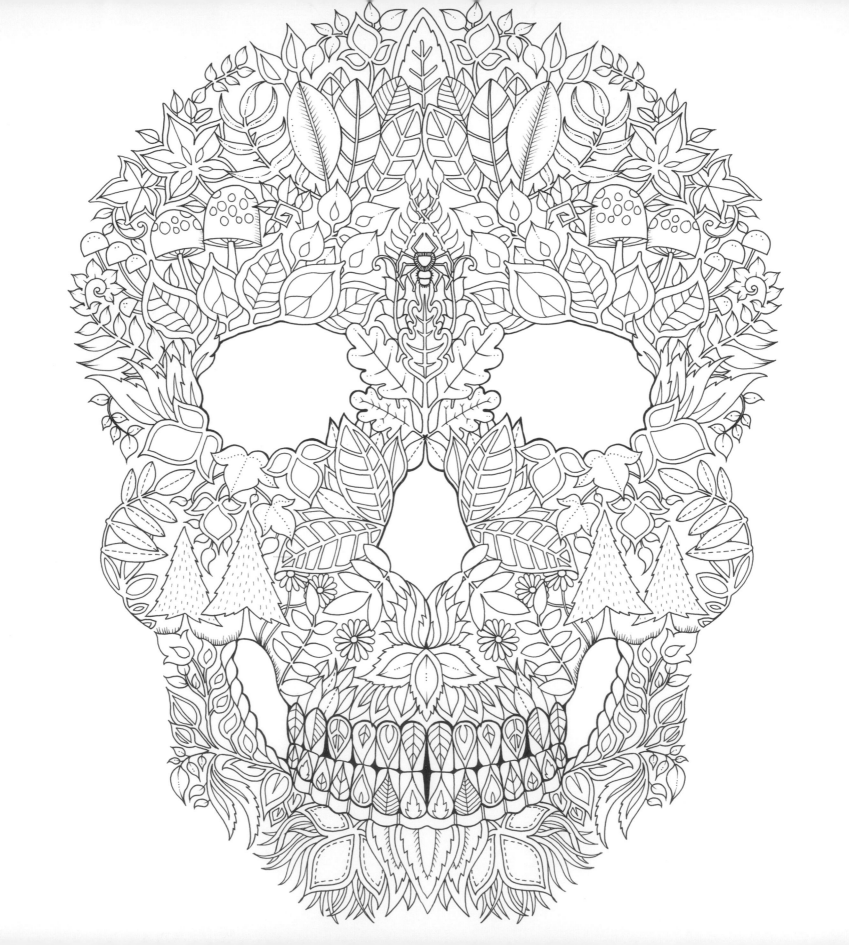

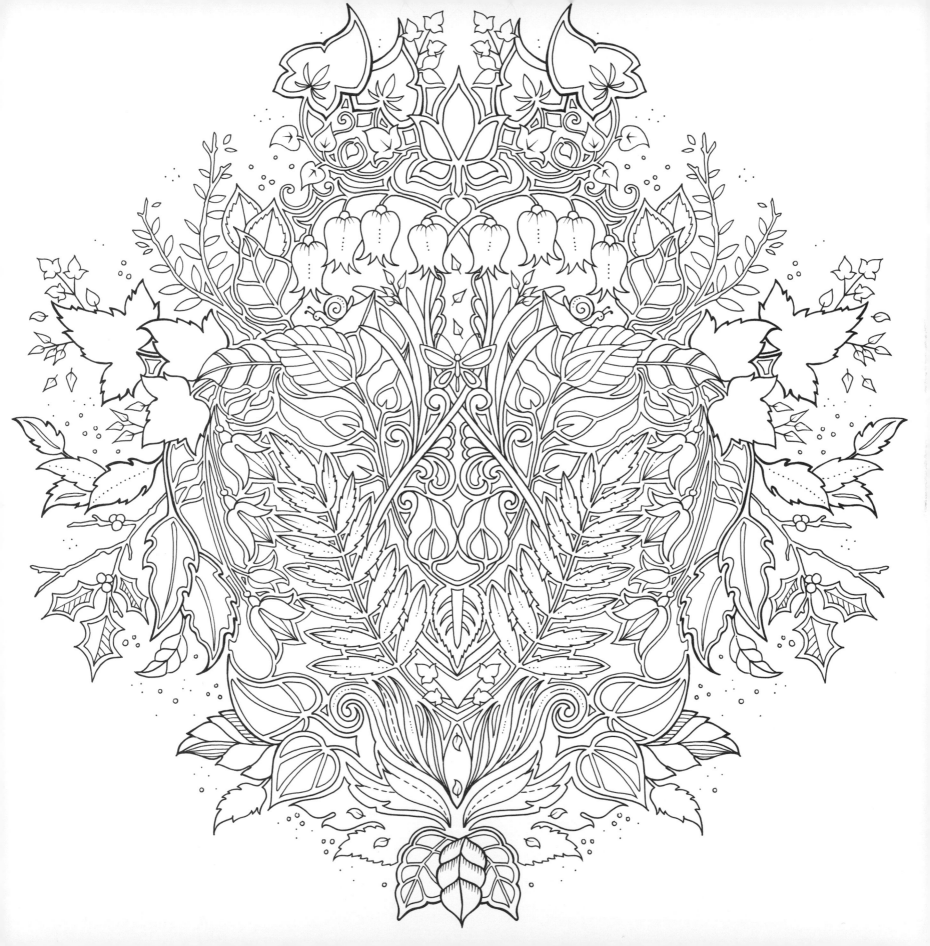

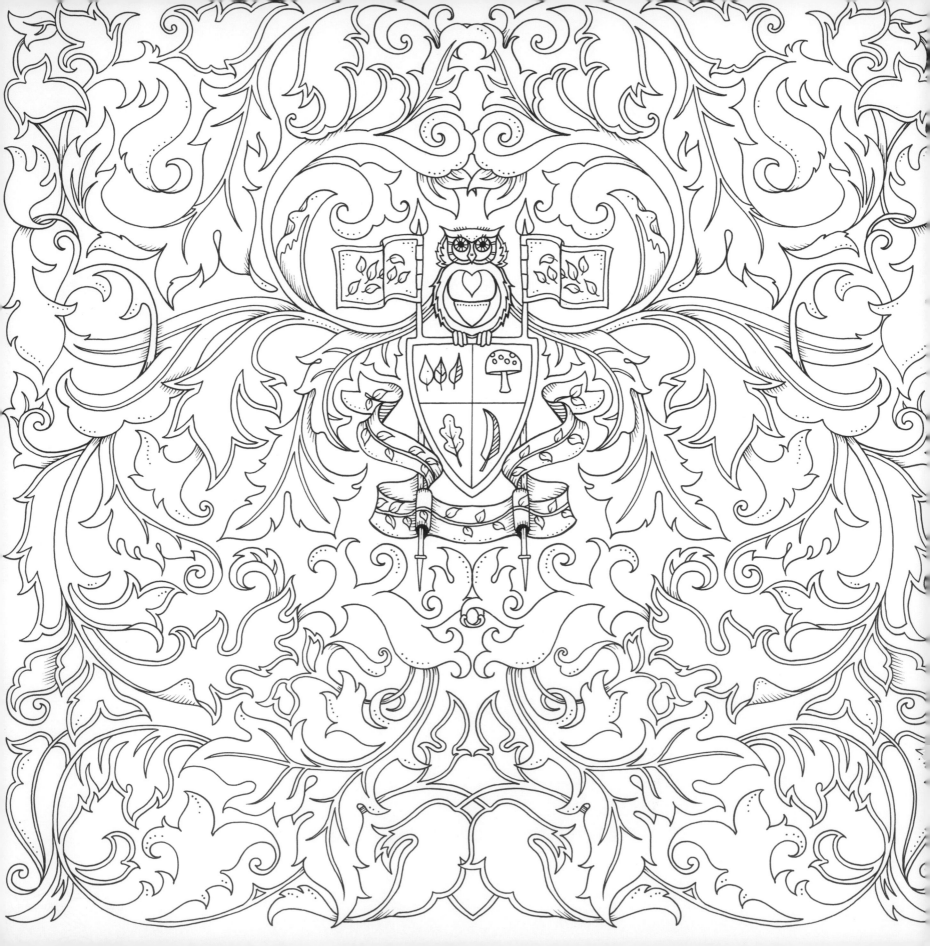

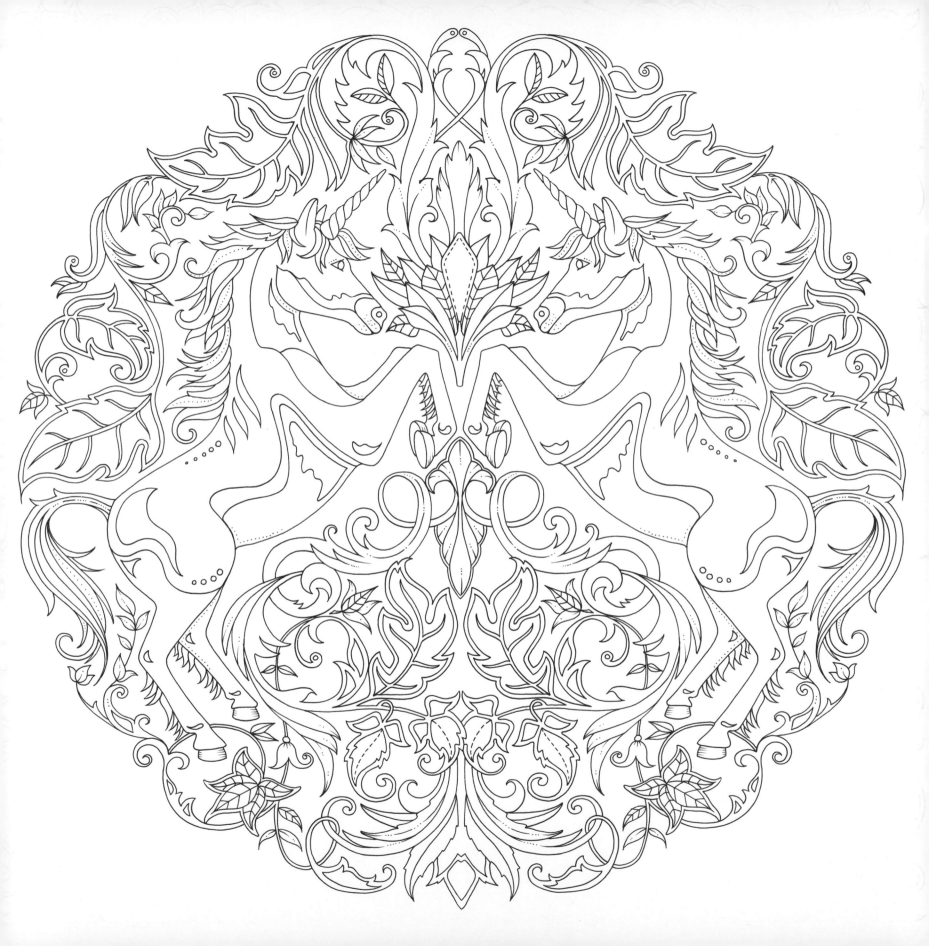

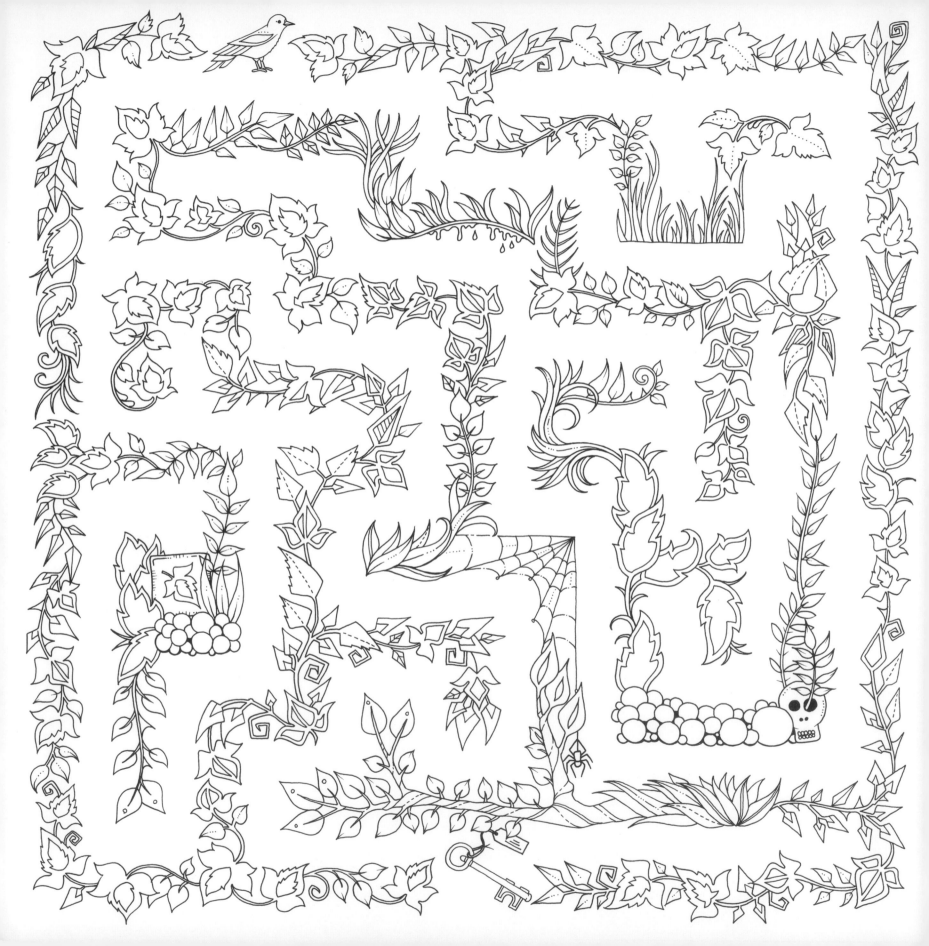

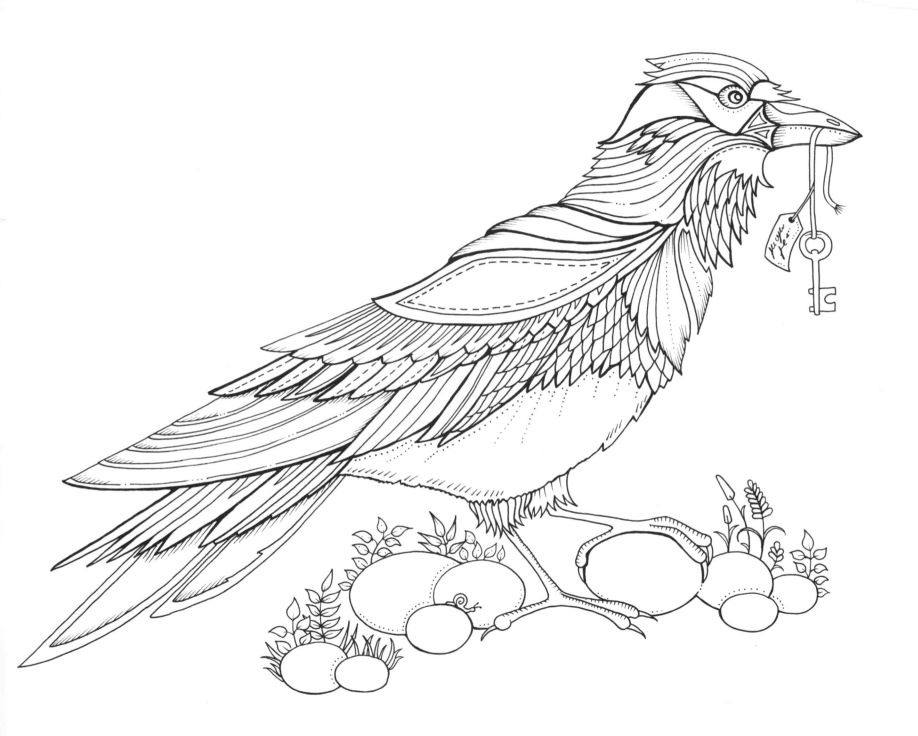

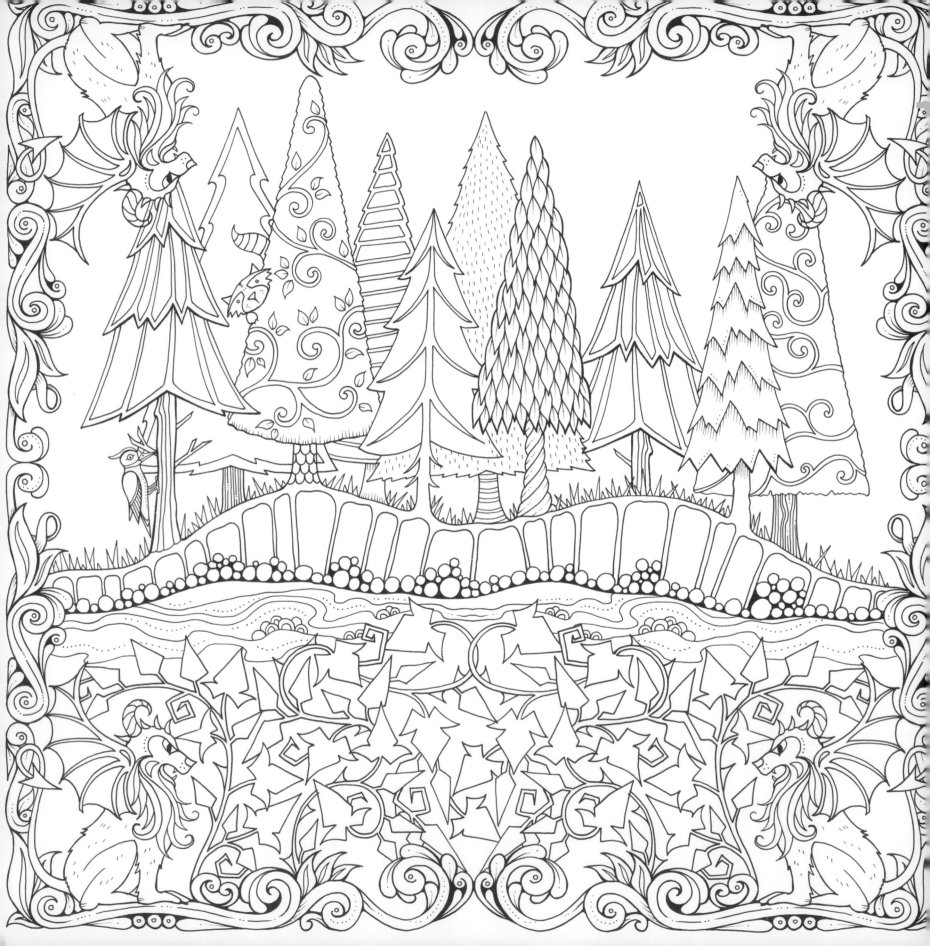

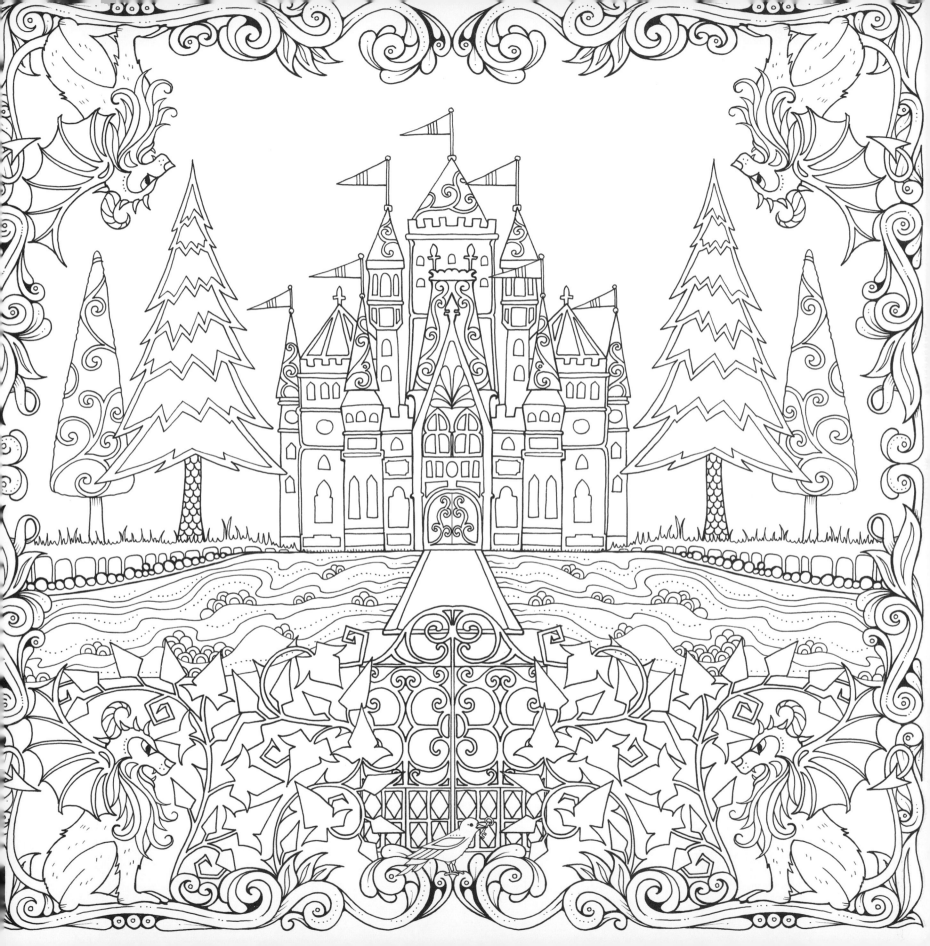

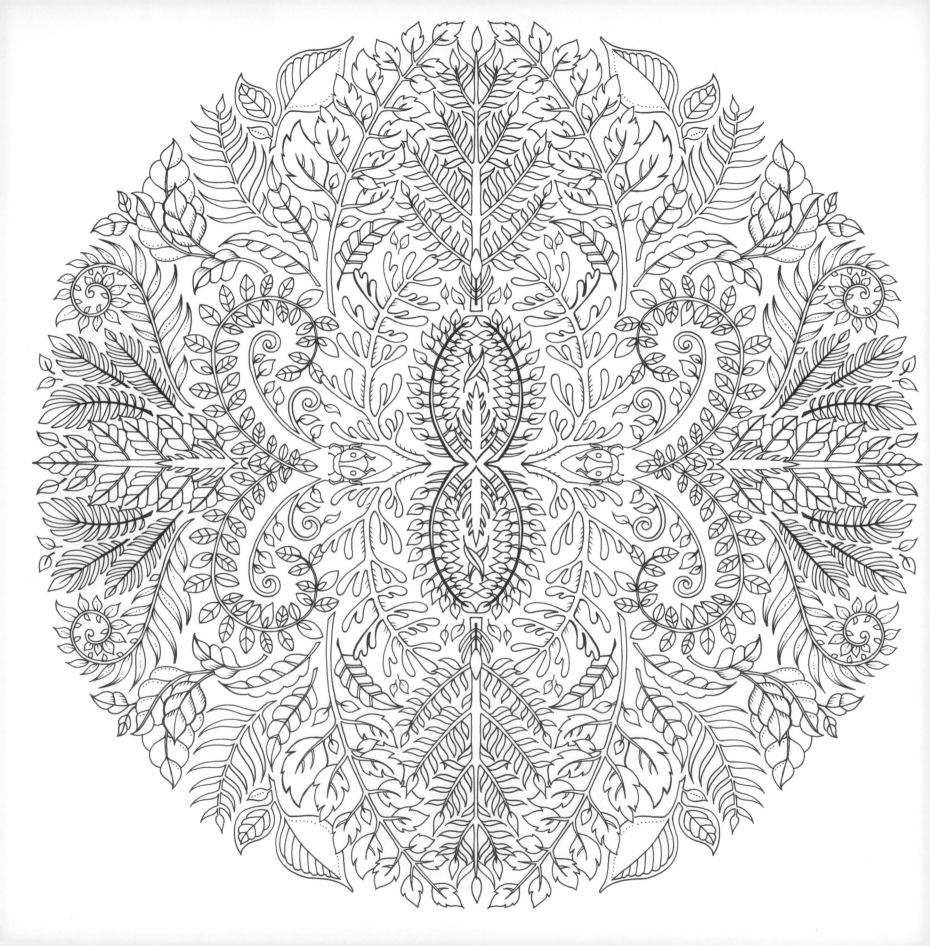

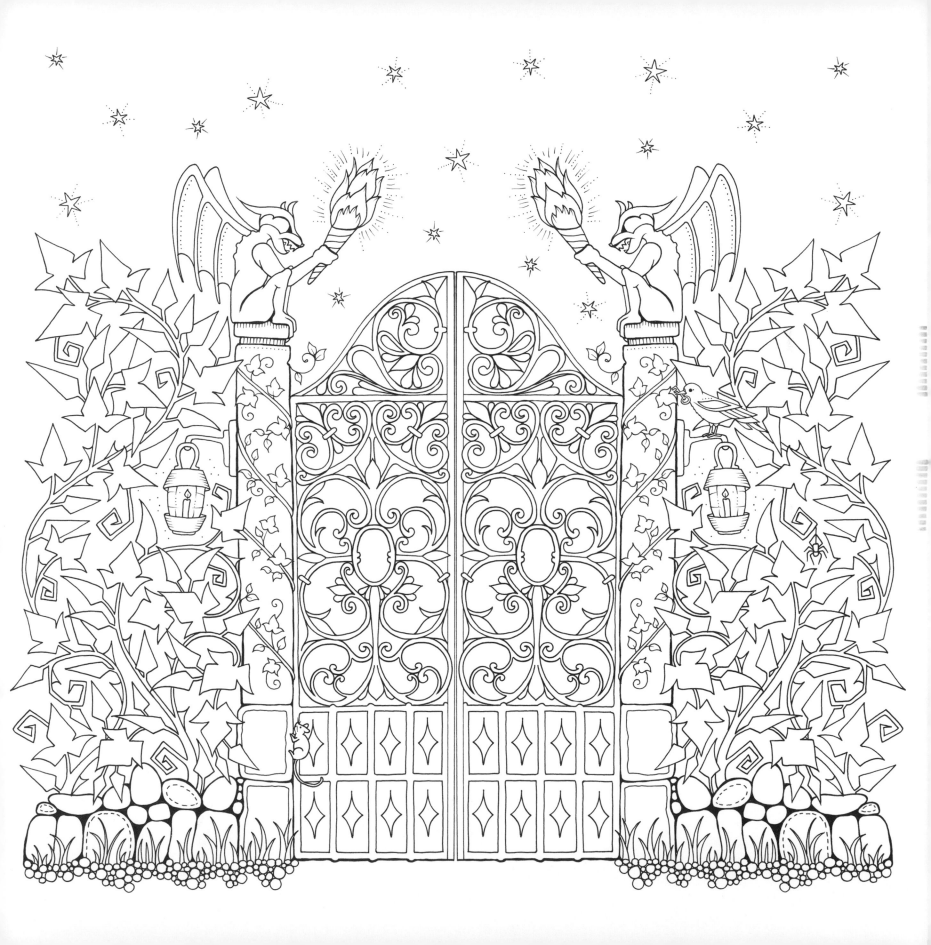

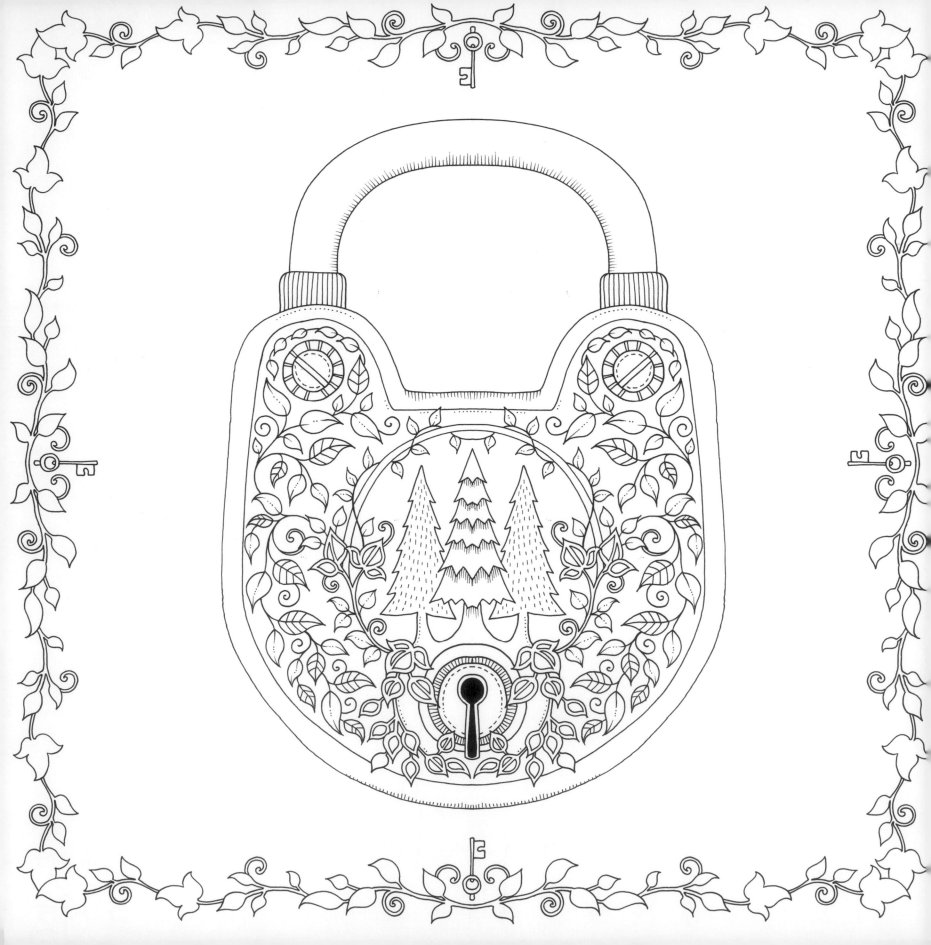

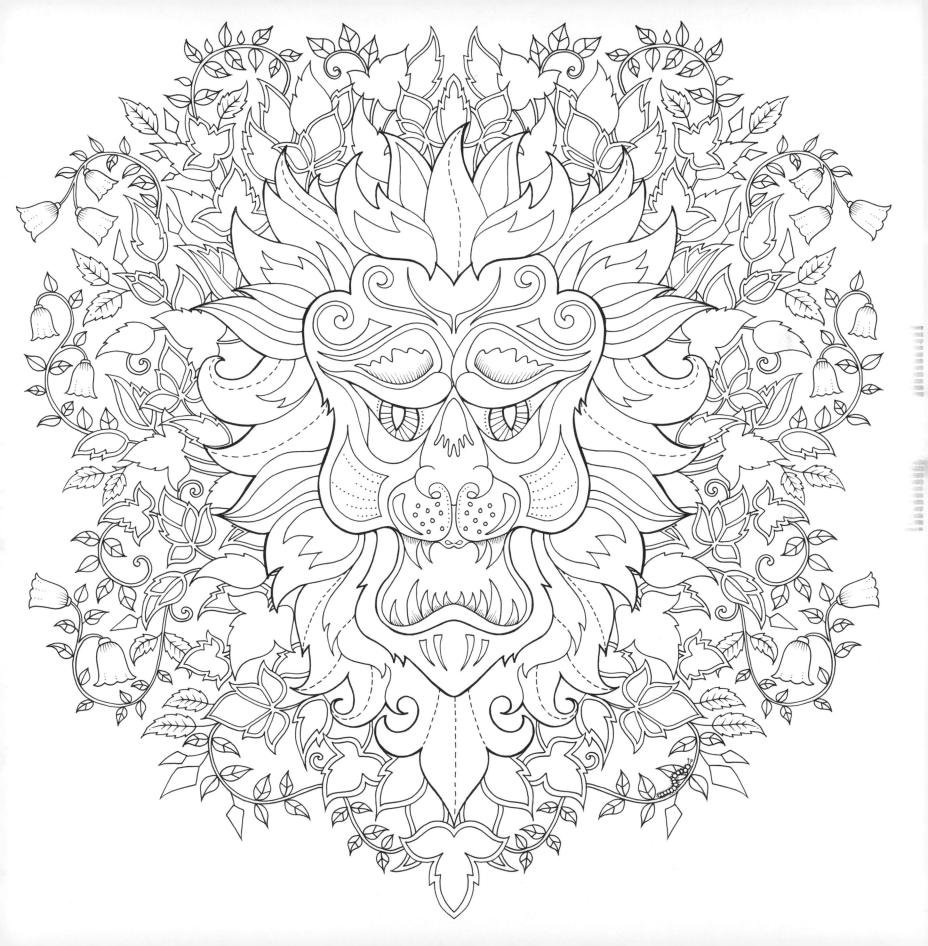

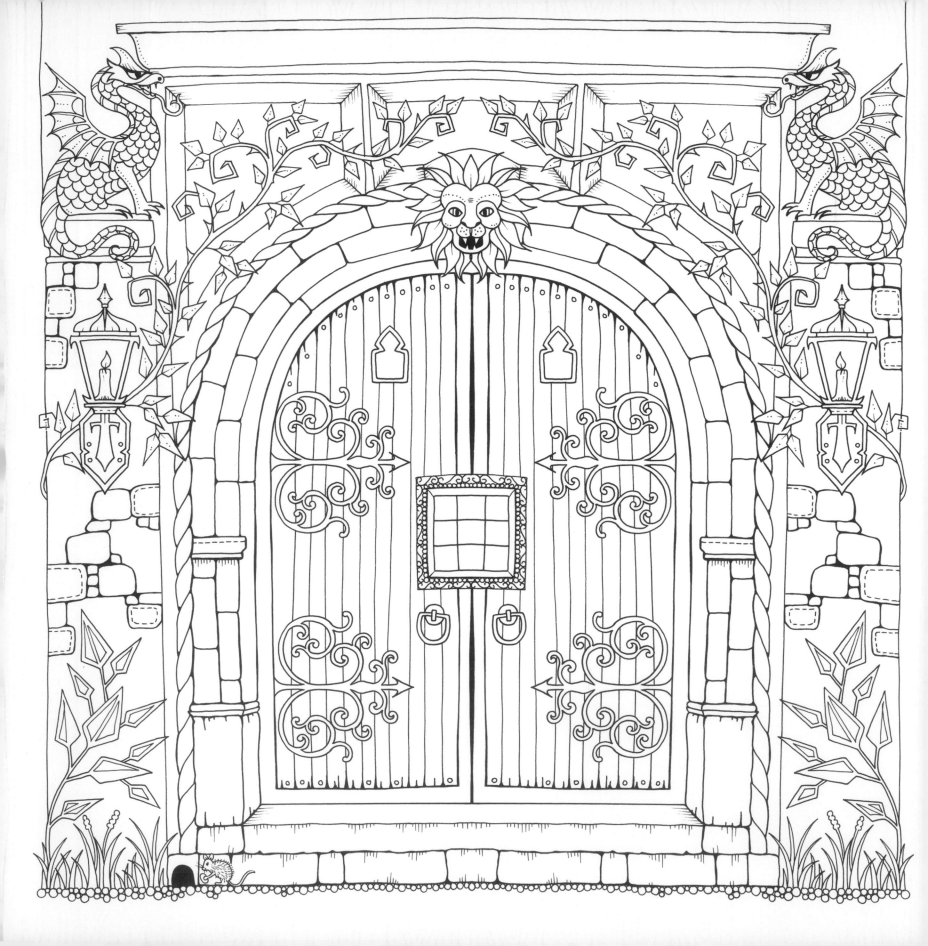

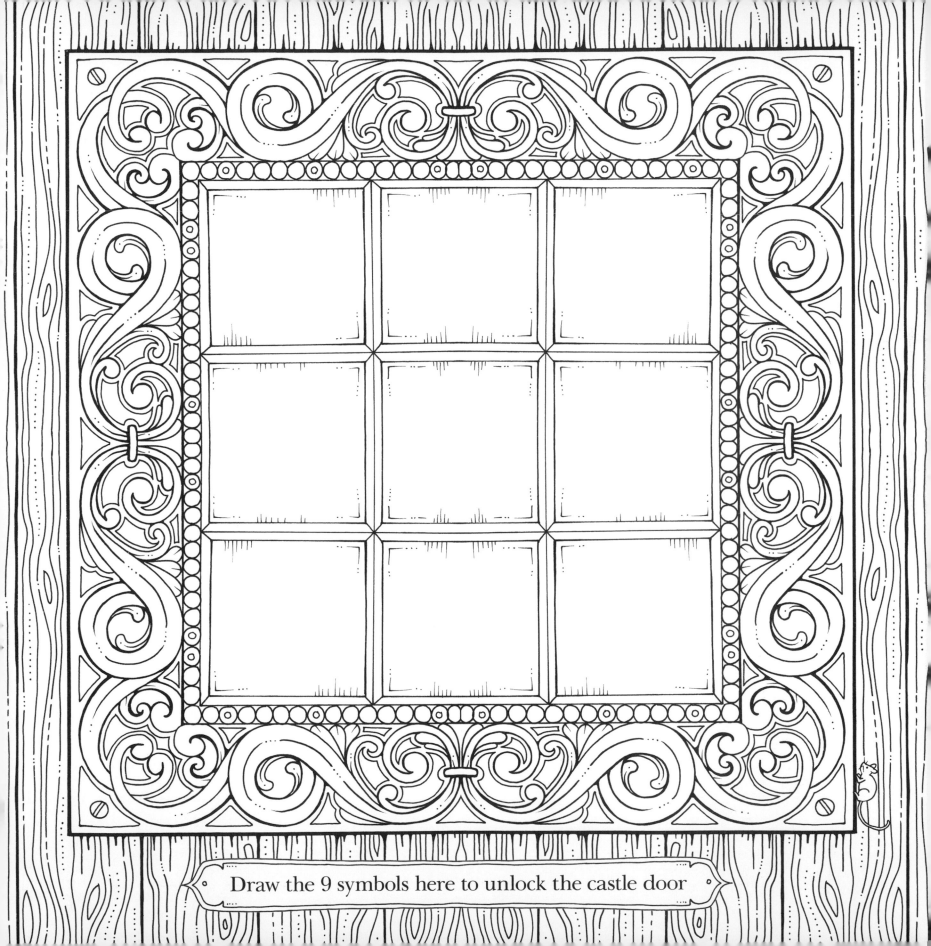

Draw the 9 symbols here to unlock the castle door

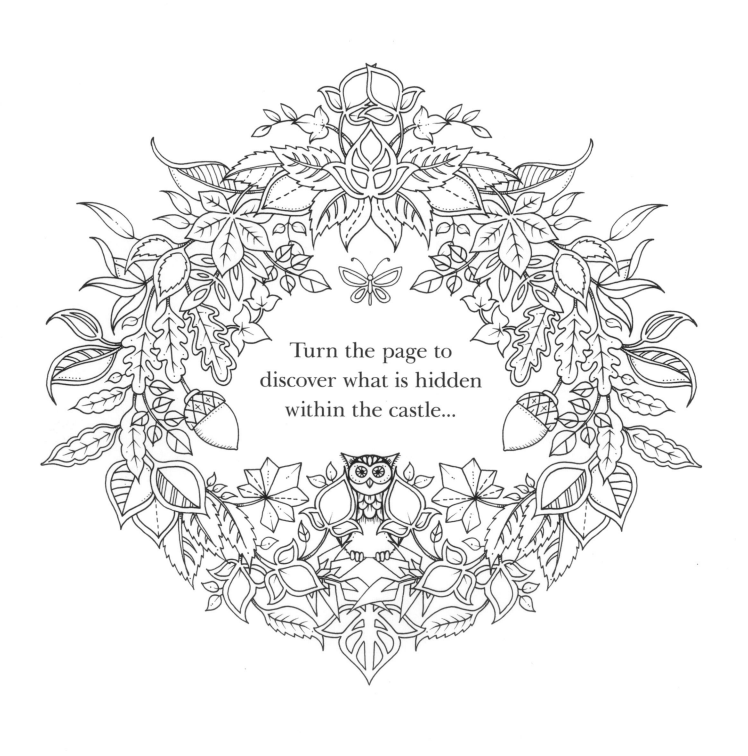

Turn the page to
discover what is hidden
within the castle...

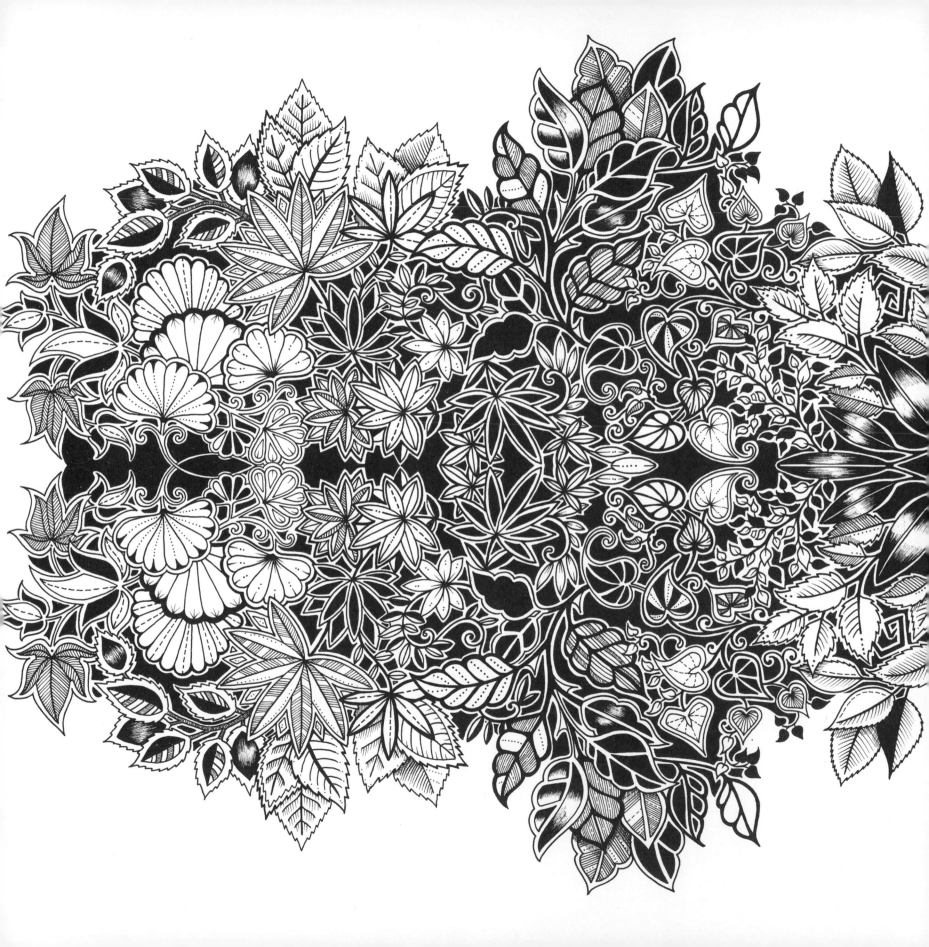

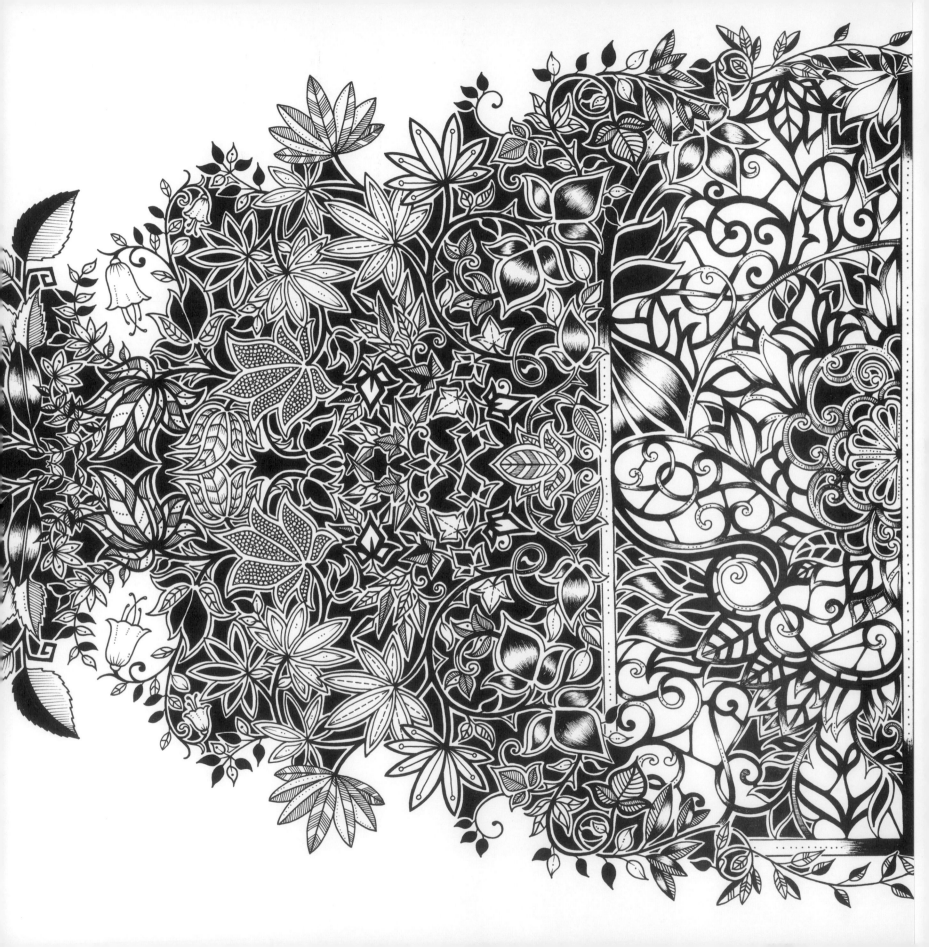

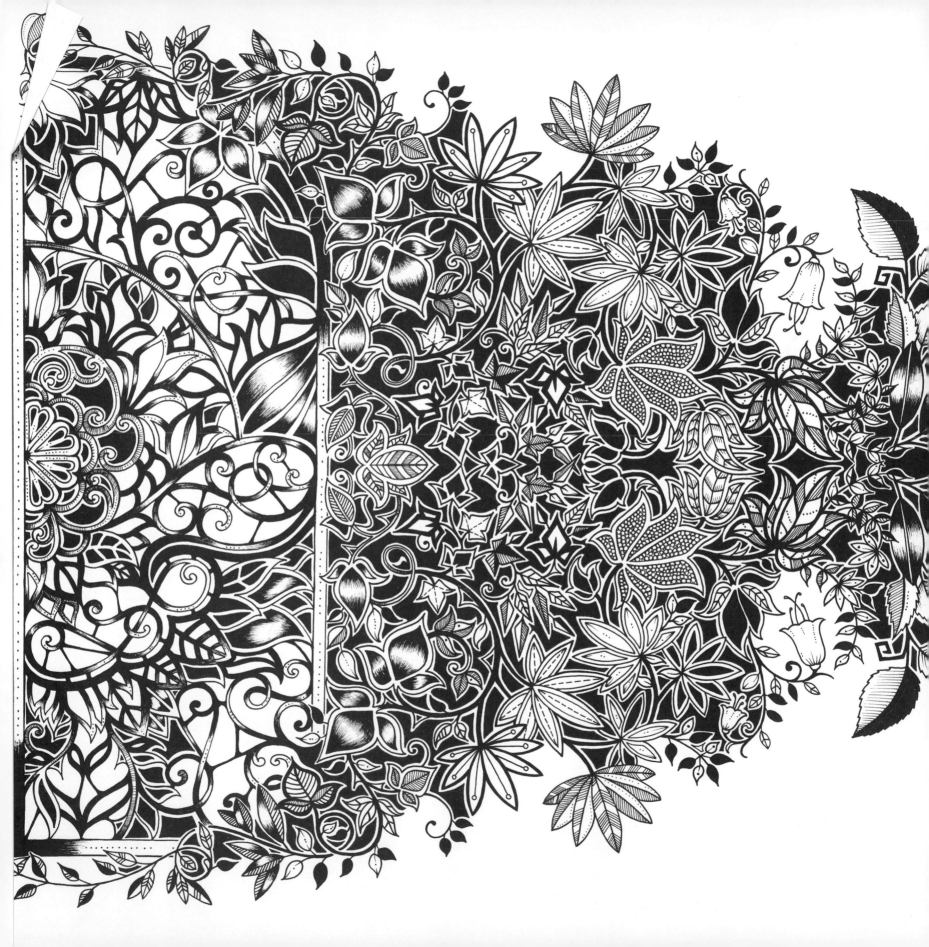

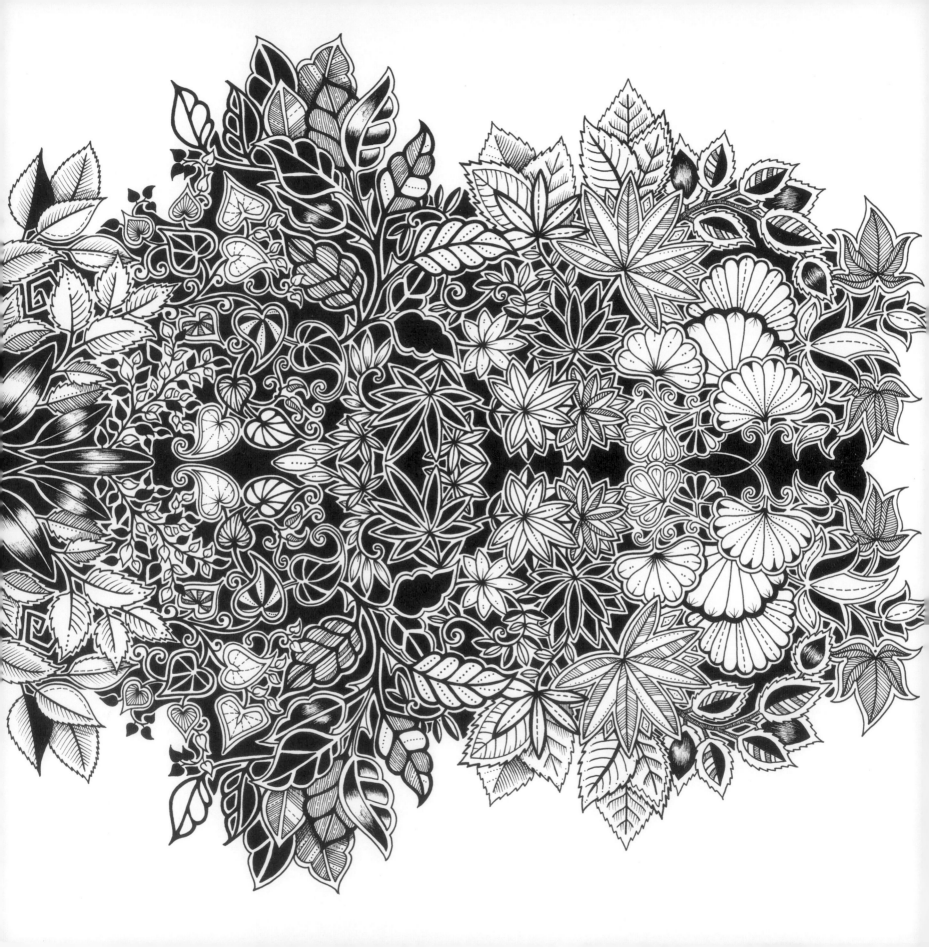

Key to the Enchanted Forest

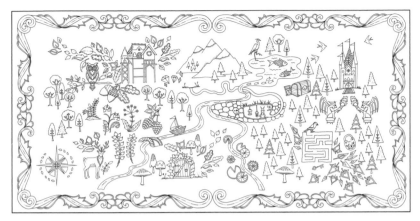

7 fish, 4 birds, 2 gargoyles, 1 deer, 1 rabbit, 1 heron, 1 owl,
1 hour glass, 1 treasure chest

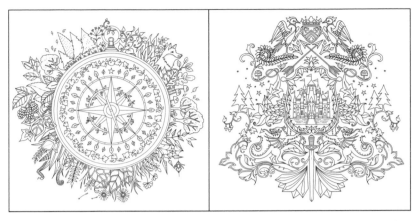

1 fox, 1 spider, 1 caterpillar

2 birds, 2 gargoyles, 2 arrows, 1 sword

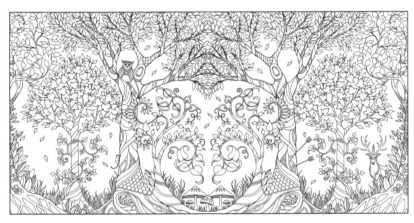

2 arrows, 1 owl, 1 deer, 1 mouse

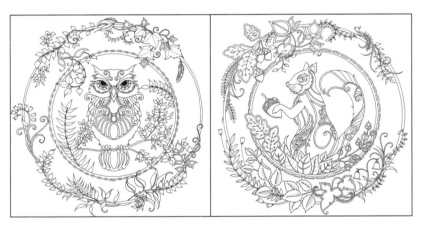

1 owl

1 squirrel

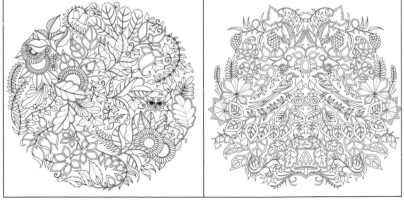

1 owl, 1 symbol

2 birds

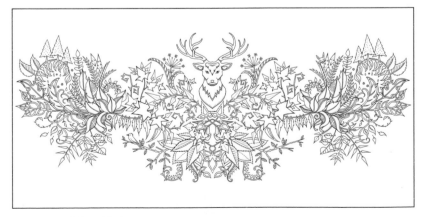

1 deer, 1 rabbit, 1 bird

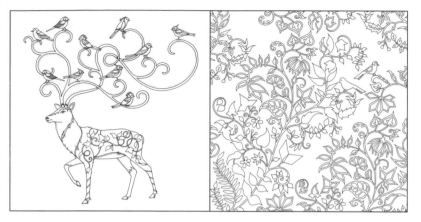

10 birds, 1 deer

2 birds

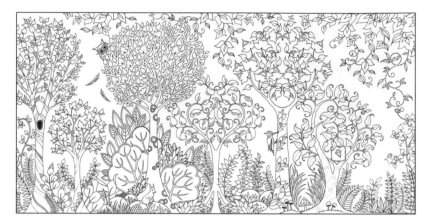

1 rabbit, 1 owl, 1 woodpecker, 1 mouse, 1 symbol

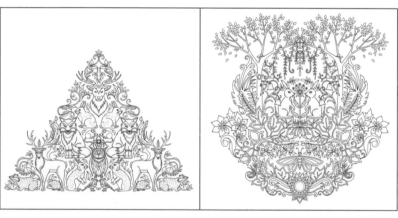

4 rabbits, 3 deer, 2 birds,
2 hedgehogs, 2 badgers, 2 mice,
2 squirrels, 2 foxes, 1 owl, 1 spider

2 rabbits, 1 butterfly, 2 woodpeckers

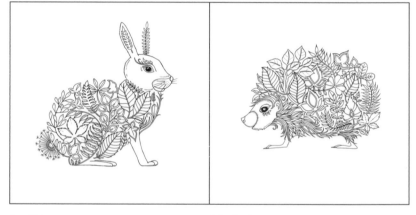

1 rabbit

1 hedgehog

1 beetle

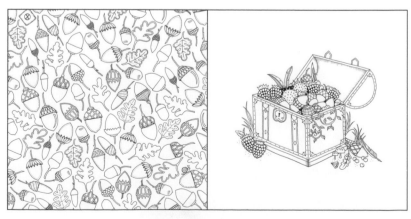

1 snail, 1 symbol

1 gem

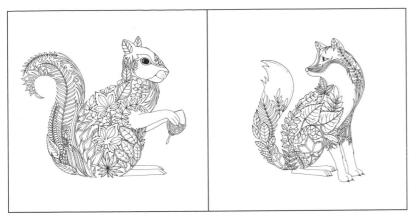

1 squirrel

1 fox

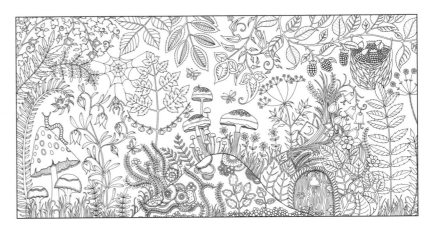

3 butterflies, 1 spider, 1 caterpillar, 1 ladybird, 1 snail, 1 symbol

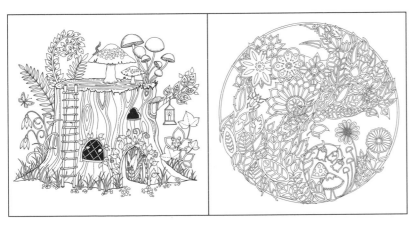

1 butterfly, 1 woodlouse,
1 ladybird, 1 caterpillar

1 beetle

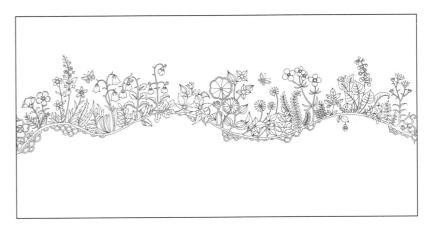

2 butterflies, 1 spider, 1 snail

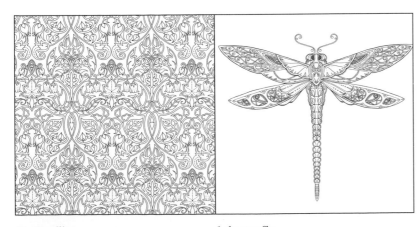

4 butterflies

1 dragonfly

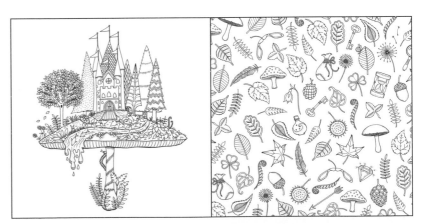

2 fish, 1 caterpillar, 1 rabbit

2 keys, 1 magic flask, 1 magnifying glass,
1 gem, 1 snail, 1 hourglass, 1 arrow,
2 pouches of magic beans

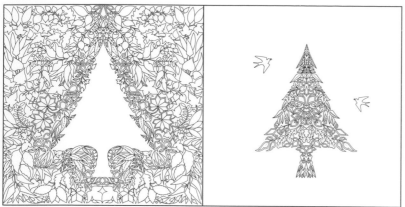

2 birds

3 birds

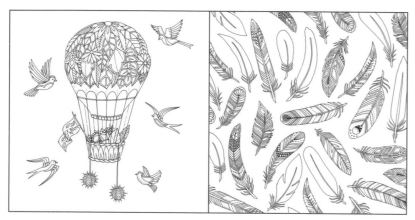

5 birds

1 butterfly

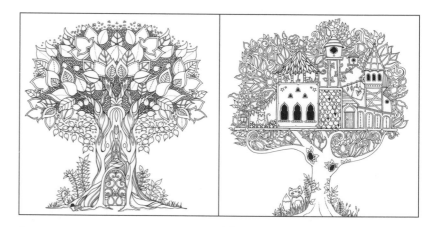

1 mouse

1 fox, 1 cat, 1 symbol

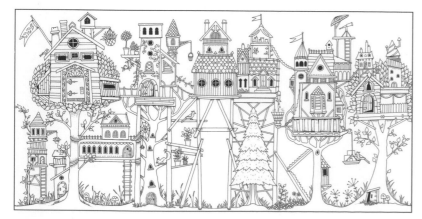

3 birds, 1 rabbit, 1 squirrel, 1 spider

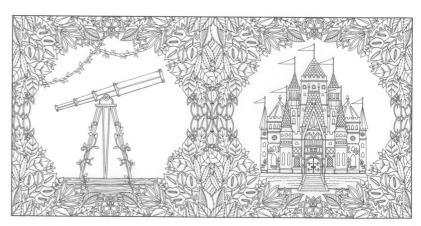

1 snail

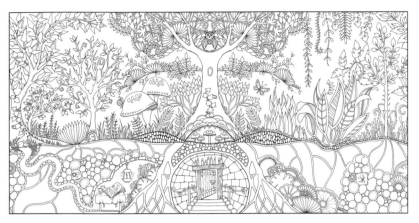

1 rabbit, 1 snail, 1 owl, 1 butterfly, 1 symbol

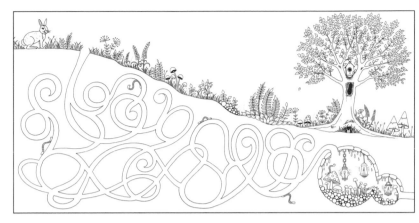

5 worms, 2 rabbits, 1 key

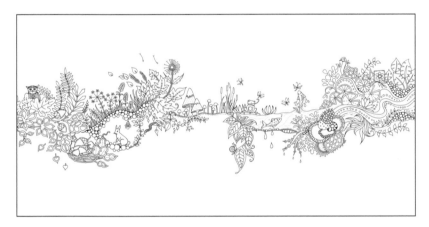

4 dragonflies, 2 fish, 1 owl, 1 rabbit, 1 worm, 1 spider, 1 caterpillar,
1 snail, 1 frog, 1 lost penguin, 1 symbol

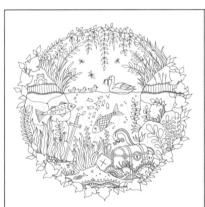
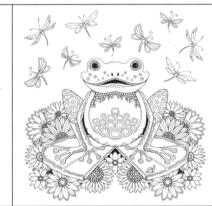

12 fish, 3 ducklings, 3 dragonflies,
1 eel, 1 snail, 1 frog, 1 duck, 1 key,
1 sword, 1 treasure chest, 1 symbol

9 dragonflies, 1 frog, 1 snail,

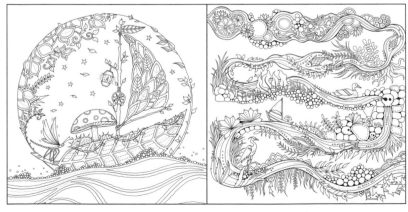

1 dragonfly

13 fish, 1 heron, 1 snail, 1 duck, 1 frog

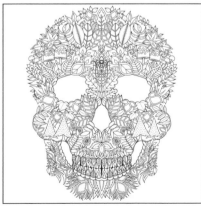
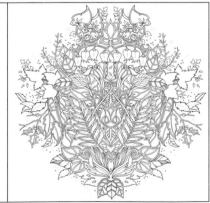

1 spider

2 snails, 1 butterfly

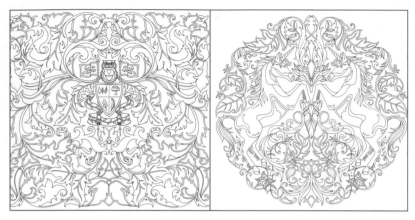

1 owl

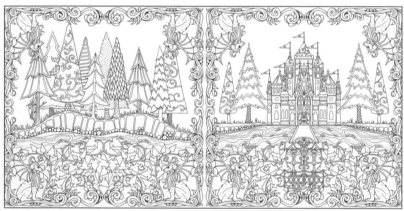

2 unicorns

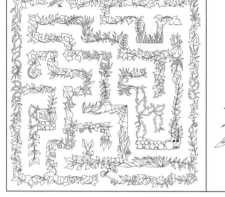

1 spider, 1 bird, 1 key, 1 symbol

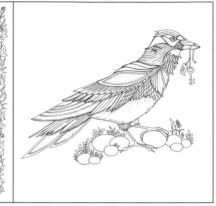

1 bird, 1 snail, 1 key

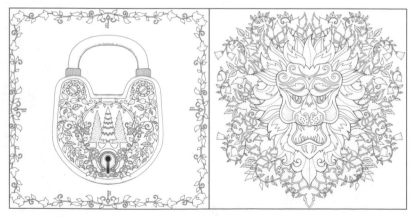

8 gargoyles, 1 raccoon, 1 woodpecker, 1 bird, 1 key

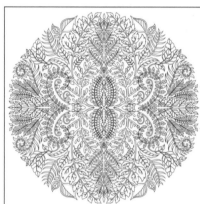

2 ladybirds

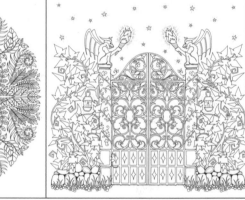

2 gargoyles, 1 bird, 1 spider,
1 mouse, 1 key

4 keys

1 caterpillar

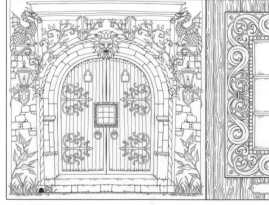

2 gargoyles, 1 mouse

1 mouse